Shimmer & SHINE WORKSHOP

Create Art that *Sparkles*

Christine Adolph

NORTH LIGHT BOOKS
CINCINNATI, OHIO
www.clothpaperscissors.com

Contents

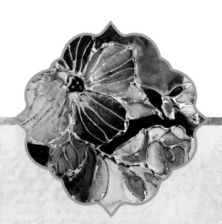
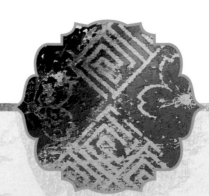
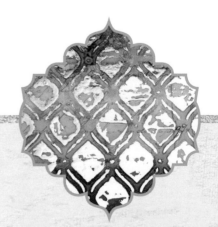

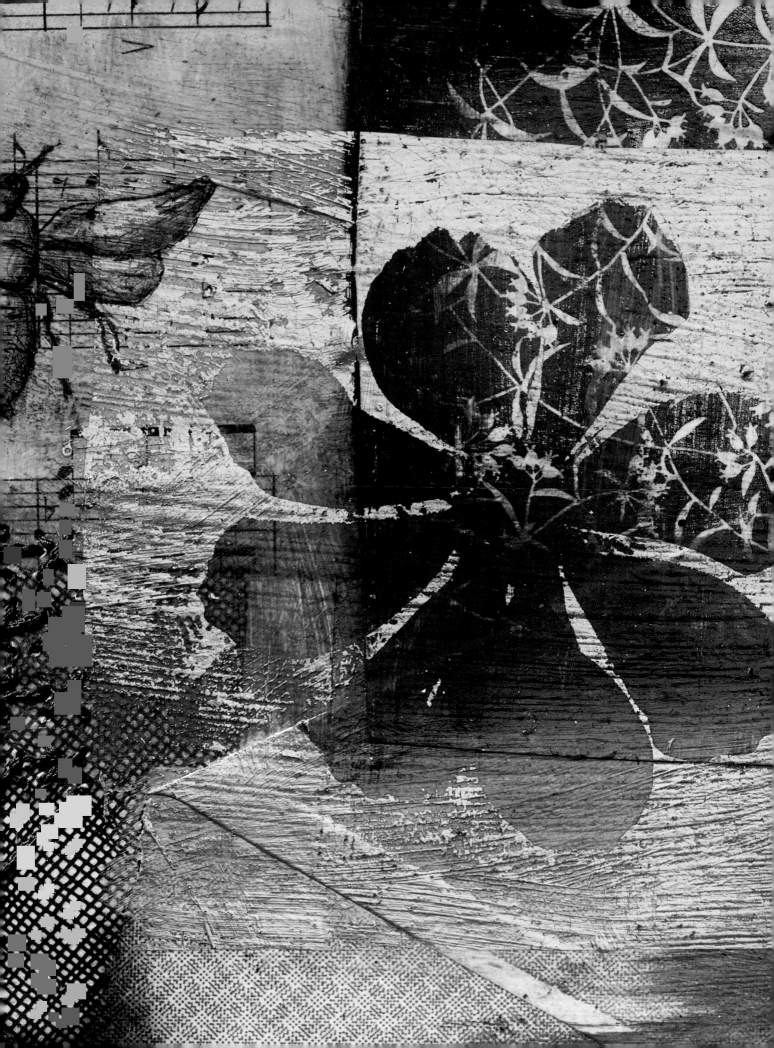

Let Your Art Sparkle

My shimmer-and-shine journey began one evening many years ago in a little fiber arts studio in Laguna Beach, California. It was 2003—way before the bling of transfer foil sparkled off every endcap of all the major craft stores. I was a stay-at-home mom with two babies and was longing for a creative outlet. My husband's grandmother, Vida, suggested I go visit with a distant cousin, a fiber artist named Cheryl Stone, to get a lesson on her Iowa Foil Printer. Little did I know that this one night would make a significant impact on me by introducing me to transfer foil, a material that has become a signature element in my art and design.

To be honest, I was hesitant about the idea of using these shiny transfer foils. All that I had been exposed to were tacky rainbow holographic foils, and I wasn't too interested in those. My preconceptions disappeared that evening as I played with endless rolls of foil. Following this night, I spent many hours at Cheryl's studio, babies in tow, creating foiled mixed-media artwork. Realizing I couldn't afford a foil printer, I set out to find ways to get the same results more economically. This led me to experiment with a laminator and irons, which put me on a mission to try every glue and medium I could find to adhere foil.

The first part of this book is devoted to sharing my years of playful discoveries with transfer foils. The second part focuses on other favorite sparkly mediums I've grown to love, and I hope by the time you're finished reading you will love it all, too.

Tools and Materials

The list gives you the materials and tools we'll use in this book. The pages that follow give you a bit more information. As with any artistic process, it's best to experiment with a variety of options to determine what works best for you and your creative goals.

ADHESIVES

- adhesive dots, lines, rub-ons and sheets
- clear spray finish
- craft glue
- foil glue
- fusible spray adhesive
- glue pen
- glue stick
- soft gloss gel
- sticky embossing powder
- tape runner
- transfer foil adhesive

SPARKLE MEDIUMS

- acrylic paints: high flow, interference, iridescent, metallic and shimmering
- art glitter

- copper embossing powder
- liquid gold leaf
- metallic ink pads
- metallic wax
- mica sprays (Color Bloom Sprays)
- transfer foils

OTHER MEDIUMS

- 3D Gloss Gel (Prima Marketing)
- absorbent ground (Golden)
- acrylic spray sealant
- clear embossing ink
- concentrated watercolors
- encaustic medium
- gouache (black)
- Mod Podge
- molding paste (Prima Marketing)
- pan watercolors
- spray paint (gold)
- water-soluble inks
- water-soluble oil pastels

SURFACES

- bristol paper
- canvas
- cardstock
- cotton fabric
- glass vase or other vessel
- oval canvas placemats (Fredrix)
- rice paper
- scrapbook paper
- toner (laser) photocopies
- watercolor paper
- wood panel
- Yupo paper

TOOLS

- bleach pen
- brayer
- burnishing tool
- craft/quilting tacking iron with mouse pad
- die-cut machine or hand punches
- foam brushes
- Gelli Printing Plate
- heat gun
- HotFix crystal tool
- laminator
- mini slow cooker
- moldable foam stamps
- paper palette
- paper towels
- pencils
- rubber stamps
- scissors
- spackle knife
- spreader or paint scraper (old gift cards)
- Stabilo All pencil
- stencil brushes
- stencil cutter/burner tool
- water brush
- watercolor brushes
- watercolor resist pen

OTHER

- bleach
- crystals
- Dura-Lar film (Grafix)
- glass sheet
- painter's tape
- stencils
- tape (clear)

Making It Stick

My advice to you when working with adhesives is to be curious and be open. Be open to experiment with a wide range of adhesives and substrates; try things that are both conventional and unconventional. For example, I was curious if foil would stick to a glossy photo, and to my surprise it stuck beautifully with just a touch of heat from a craft iron.

Be open to imperfections and go with them; make them work for you and at the same time, learn from them. If you are open to the process, your own unique ways of working with transfer foils will emerge.

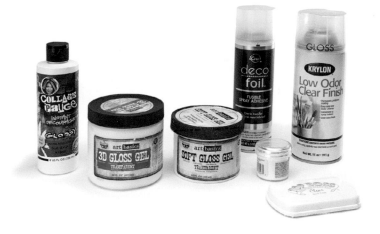

Acrylic mediums (Collage Pauge Glossy, Prima 3D Gloss Gel, Prima Soft Gloss Gel), fusible spray adhesive, clear coat spray

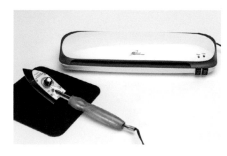

Craft/quilting tacking iron, heat-resistant mouse pad, 12" (30cm) laminator

Clear adhesive dots—a variety of sizes, toner sheets, adhesive sheets, foam adhesive sheets

Adhesive rub-ons, glue stick, tape runner, foil glue, glue pen

Adhesives Requiring Heat and Heat Tools

With the help of a heat tool (a laminator or a tacking iron), transfer foils will stick to many glossy surfaces, as well as mediums containing polymer (acrylic mediums, clear finishing spray, fusible spray adhesive, toner sheets and foil transfer adhesive). After a lot of trial and error, the glues and mediums pictured here are my personal favorites.

Adhesives That Don't Require Heat

Adhesives that remain sticky to the touch do not require heat when used with transfer foils. The foils will transfer easily by burnishing with your finger or using a burnishing tool. (Foil glue and glue pens will need to dry before adhering transfer foil.) These products include adhesive dots, rub-ons and sheets, foil glue, glue pens and glue sticks.

Making It Sparkle, Shimmer and Shine

The largest amount of attention in this book will be given to transfer foils because I use them a lot. But we'll explore other shimmery options as well, such as those listed here.

Transfer Foils

Transfer foils are widely available and come in many colors and thicknesses. Keep in mind that you can use any transfer foils with the glues that are on the market. Through your own trial and error you will find what you like.

Other Sparkly Mediums

These items can be used along with your favorite mixed-media tools including stencils, stamps and, of course, brushes. As with the transfer foils, you can add a little sparkle or a lot; use them for small details or in larger amounts for a background.

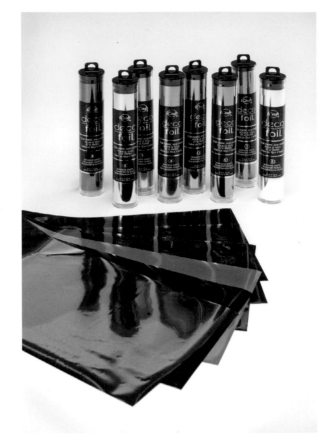

Assorted transfer foils

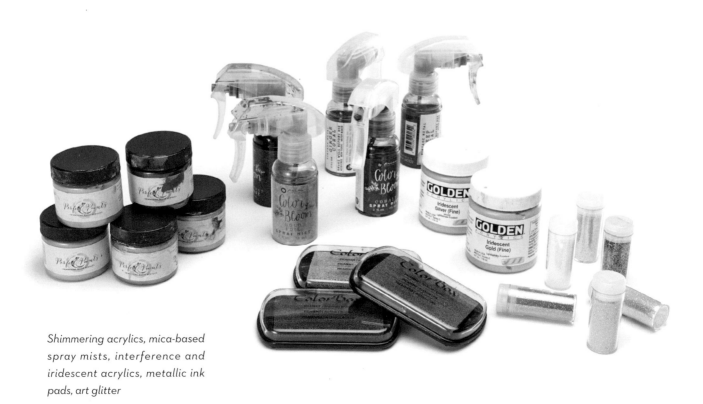

Shimmering acrylics, mica-based spray mists, interference and iridescent acrylics, metallic ink pads, art glitter

Making It Mixed Media

If you're like most artists, you're compelled to add lots of layers to your work and mix materials together. These materials represent some of my favorite papers, paints and tools I like to use over and over.

Concentrated watercolors

Travel pan watercolor set, water brush, Stabilo pencils, Golden absorbent ground, modeling paste, gouache, water-soluble oil pastels

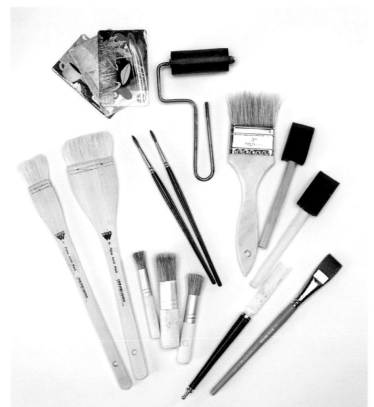

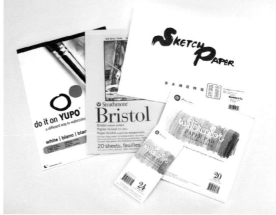

Paint scrapers, rubber brayer, chip brush, foam brushes, watercolor brushes, stencil brushes, Japanese wash brushes

(top) Assorted rubber stamps

(bottom) Yupo, bristol, rice paper, watercolor paper

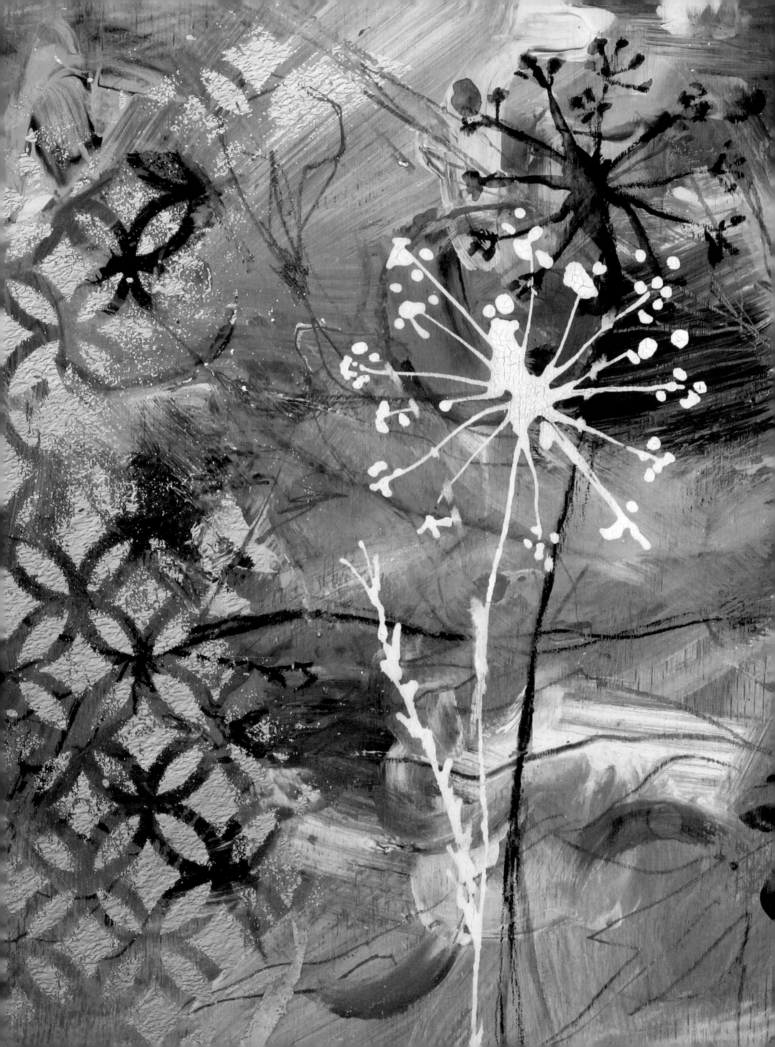

Foiling Around

{ TECHNIQUES FOR ADDING
TRANSFER FOILS TO YOUR ART }

When I mention using foil in my artwork, many people get confused and think I'm referring to aluminum foil or some kind of metal sheeting. A more accurate term for what I use is *transfer foil*. Artists and crafters commonly use metallic transfer foil, as it's the easiest type of foil to find. Transfer foils also come matte, clear, tinted, pigmented, pearl, holographic, patterned and more. (See more about transfer foils in the Tools and Materials section preceding this chapter.)

Transfer Foil consists of three layers:

TOP: Clear plastic film
MIDDLE: A color or pattern
BOTTOM: Dull color layer, often silver or light gold

Transfer foil needs adhesive to grab it and pull it off the plastic film top layer. That is why you should always use the foil "color or pretty side up." Many people intuitively want to put it color side down. If you find that your transfer isn't working, perhaps you put the foil upside down; try the other side and see if it works. Silver can be tricky because there is a silver shiny top side (clear plastic film) and a dull silver bottom. Just remember: It's dull side down and pretty side up.

In this section we will review different types of adhesive for transfer foil and several techniques for adhering it to toner copies, papers, fabric, wood, photos, wax and glass. I'll share how to integrate foil with some of my favorite mixed-media and surface-design techniques such as working with masks and stencils, creating resists and faux resists, and experimenting with gouache and concentrated watercolors. Also, I will teach you how to maximize your foil sheets by using the negative images you pull away when you transfer your foil to your substrates. I never throw a piece of foil away until every bit of foil is off of it, and I'm hoping these techniques will help you see how far you can stretch all of your scraps of foil, too.

Creating a Foil Negative

There is a huge trend of adding transfer foil to scrapbook pages, cards and mixed-media art via fancy foil machines. While the machines are a great way to apply foil, this process can also be done using a less expensive laminator or an iron. With heat, the foil sticks to the toner and leaves a beautiful sparkly impression anywhere the black toner is. The most amazing part of the process for me is pulling the foil off the copy to reveal the foil negative. Many people discard these lovely negatives and many people save them but don't know how to integrate them into their art.

WHAT YOU NEED

- laminator with carrier or tacking iron and mouse pad
- toner (laser) photocopies
- transfer foil
- watercolor paints and brush

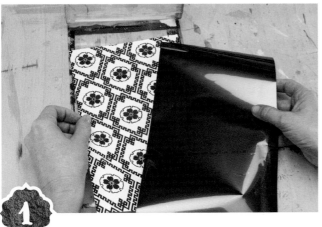

1 Preheat the laminator or iron for 10 minutes. While you wait, cut a piece of foil to fit onto your laser copy.

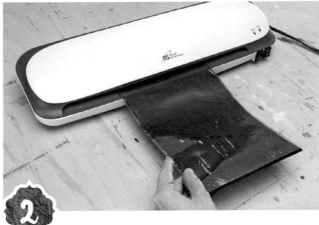

2 Run it through the laminator or use an iron to fuse the foil to the toner.

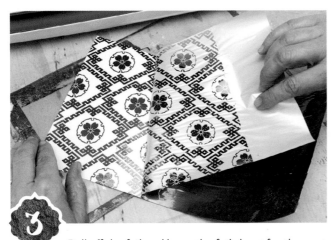

3 Pull off the foil and keep the foil sheet for the next demonstration where we will use the foil negative.

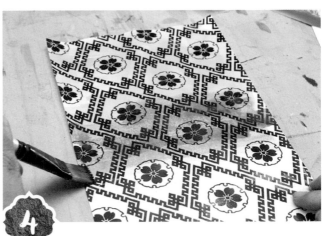

4 Hand-color by painting with watercolor. The foil will resist the watercolor.

Tips & Tricks

- Make your copy onto heavy cardstock, or copy onto black paper.
- Use a carrier with the laminator for added pressure.
- Always make sure you are applying the foil color-side up or "pretty-side up."
- As an alternative to the laminator, use a small quilting iron with a mouse pad underneath to fuse the foil to the copy.

Using a Foil Negative

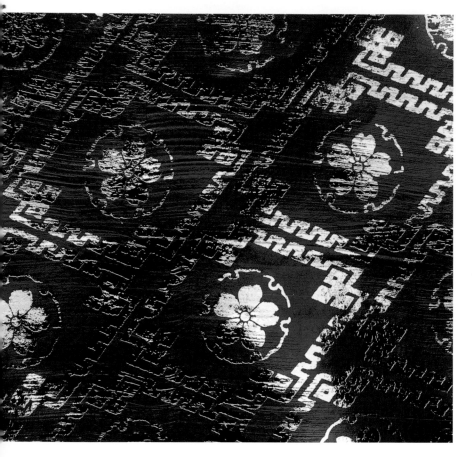

There are many ways to adhere the transfer foil negative to your chosen substrate. The adhesive I use is soft gloss gel because of its smooth consistency. Polymer medium, gel medium or even Mod Podge will work as an adhesive along with heat. I love foil on rice paper because it is easy to collage with and wrap around journals. I apply the transfer foil negatives to many substrates including watercolor paper, fabric, canvas and even photographs.

WHAT YOU NEED

- laminator with carrier or tacking iron and mouse pad
- rice paper
- soft brush
- soft gloss gel (Prima Marketing)
- transfer foil negative from previous exercise

Tips & Tricks

- I prefer soft Japanese flat brushes to apply the soft gloss gel because I avoid the heavy brushstrokes that stiffer brushes give. Experiment with various brush types.
- For a brush-stroked edge, avoid painting the glue all the way off the paper edges.

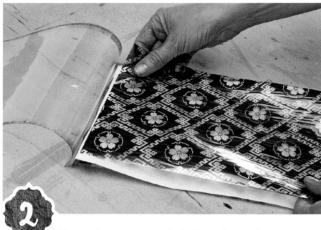

1 Using a soft brush, evenly coat rice paper with some soft gloss gel. I left a brush-stroked edge; if you don't like that look, brush the glue to the edges. Allow to dry.

2 Place the negative foil sheet from the previous demonstration color-side up over the dry medium.

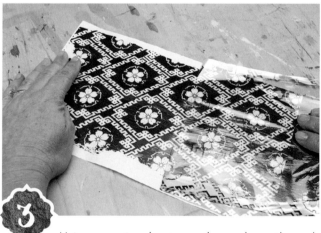

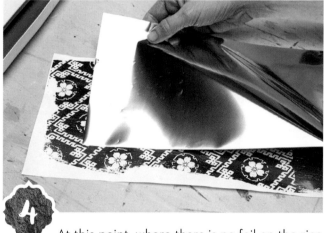

3 Using a carrier sheet, run the package through the laminator, or simply apply heat over the entire sheet using an iron.

Allow the paper to cool, then peel off the foil sheet and you'll see the remainder of the foil has transferred wherever there was adhesive on your paper. You now have another foiled sheet to work with!

4 At this point, where there is no foil on the rice paper, there will still be exposed areas of adhesive. To take this process further, choose a complementary color of foil and place it on the rice paper.

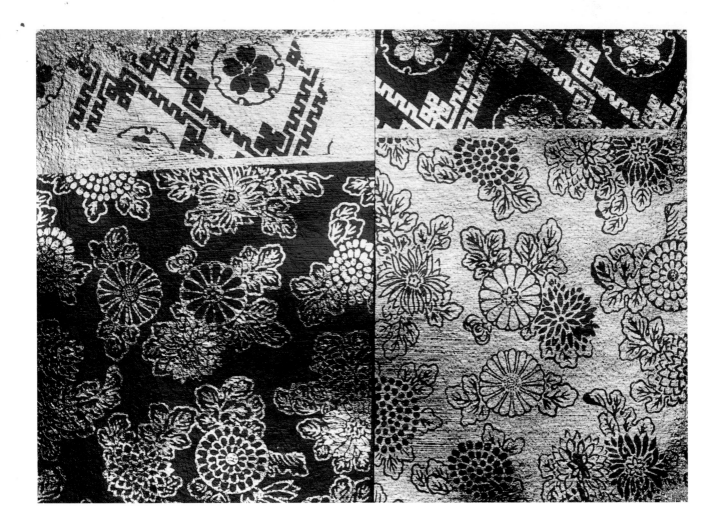

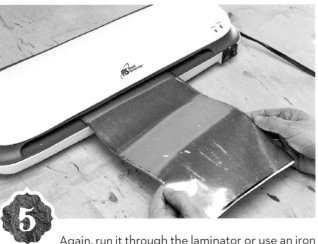

5 Again, run it through the laminator or use an iron to adhere the second color of foil to the white adhesive areas of the pattern.

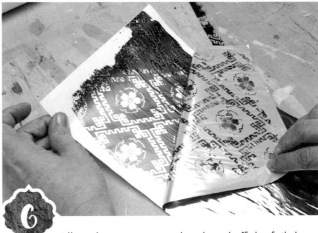

6 Allow the paper to cool and peel off the foil sheet to reveal the two-toned foiled pattern. You can repeat this process again with the negative new sheet and continue on as long as you like!

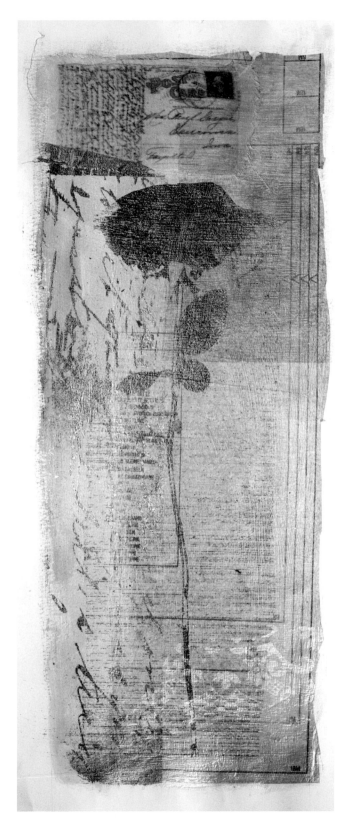

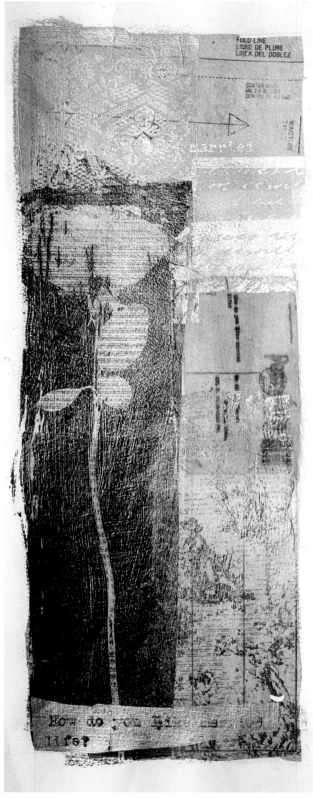

Using a Mask with a Foil Negative

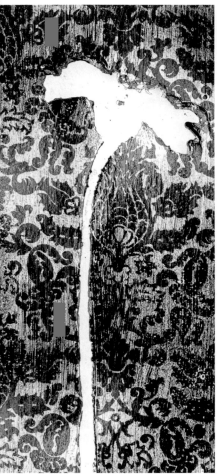

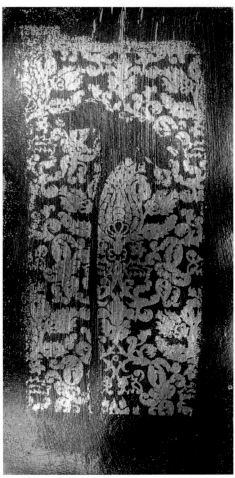

It's fun to have the foil patterns appear in certain areas of your art and not others. One way to achieve this is by brushing the soft gloss gel or other polymer-based medium through a stencil or around a mask to keep some areas without adhesive.

WHAT YOU NEED

- 6" × 12" (15cm × 30cm) 90-lb. (190gsm) watercolor paper (several sheets)
- foil negative sheet
- laminator with carrier or tacking iron and mouse pad
- negative flower mask
- soft brush
- soft gloss gel (Prima Marketing)
- transfer foil

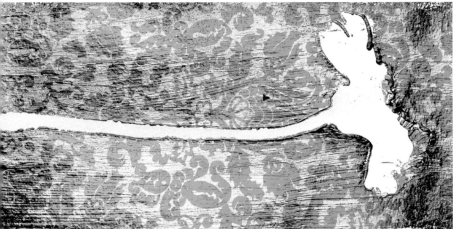

1 Center the flower mask in the middle of one sheet of watercolor paper. Using a soft brush, brush gloss gel around the mask, leaving a brush-stroked edge if desired. Let it dry.

2 Place the foiled negative on top of the dry soft gel paper with the masked area.

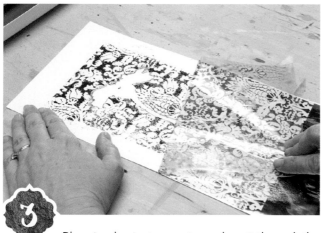

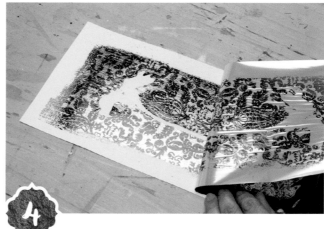

3 Place in a laminator carrier and run it through the laminator. Allow to cool and peel the foil negative off. You will have another design on the foil and can continue the process as many times as you like.

4 Place a new foil sheet in a contrasting color over the paper and run it through the laminator again. Let cool and peel off the foil negative.

Tips & Tricks

- For a mixed-media approach, create a watercolor wash or collage on the background before applying soft gloss gel and beginning the fusing process.

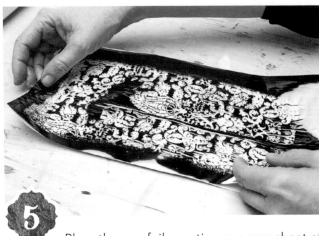

5 Place the new foil negative on a new sheet of watercolor paper that you previously covered with soft gloss gel.

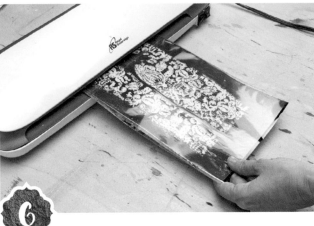

6 Place in a carrier and run the package through the laminator.

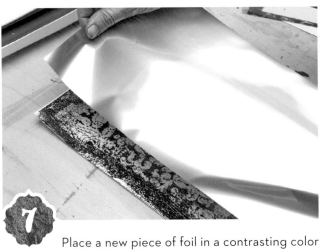

7 Place a new piece of foil in a contrasting color over the paper.

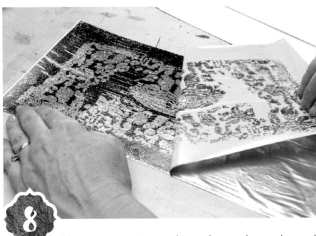

8 Place in a carrier and run the package through the laminator. Allow to cool and once more, remove the foil negative.

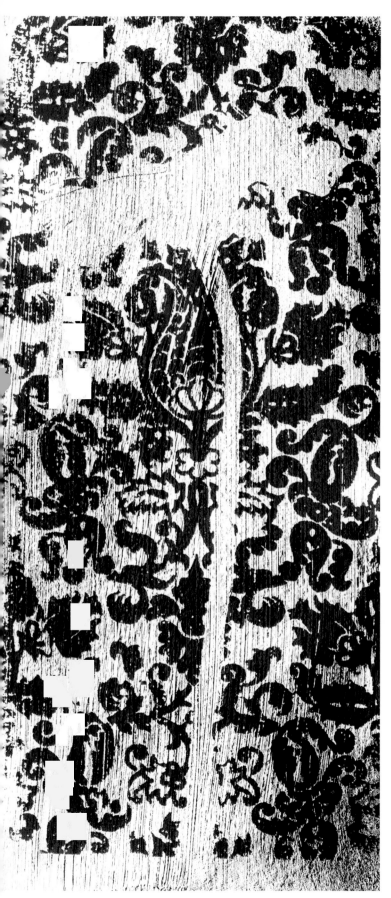
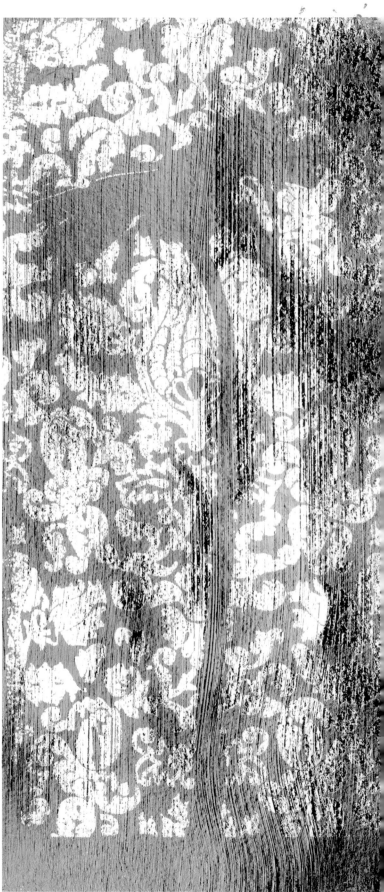

Using a Painting or Photocopy with a Foil Negative

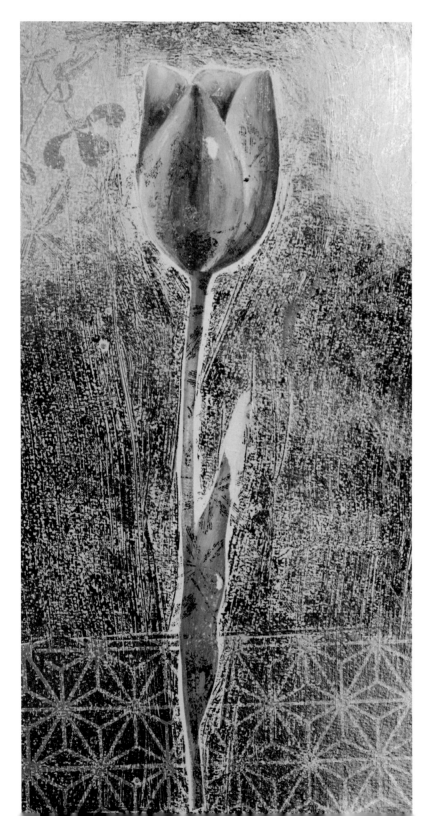

I love to have foil patterns surrounding my painted motifs. I achieve this by painting foil adhesive only in the areas around the motifs. This works especially well with watercolor paintings. If your motifs are painted in acrylic or you are using a copied image on glossy paper, you will need to mask off the motif before running it through the laminator or ironing it because acrylic paints have polymer in them, and the foil will stick to the paint in addition to the brushed-on adhesive. Feel free to use some copyright-free imagery to experiment with this technique.

WHAT YOU NEED

- 6" × 12" (15cm × 30cm) 90-lb. (190gsm) watercolor paper (several sheets)
- foil negative sheet
- image printed on copy paper and on watercolor paper
- laminator with carrier or tacking iron and mouse pad
- soft brush
- soft gloss gel (Prima Marketing)
- transfer foil

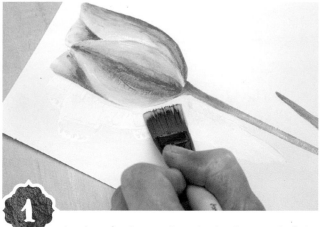

1 Apply soft gloss gel to the background of the image printed on watercolor paper.

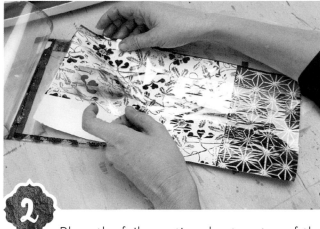

2 Place the foil negative sheet on top of the coated paper.

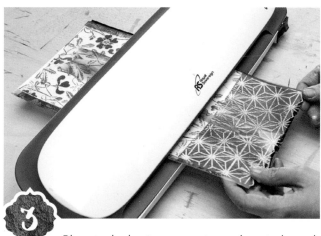

3 Place in the laminator carrier and run it through the laminator. Alternatively, you can use an iron to adhere the foil.

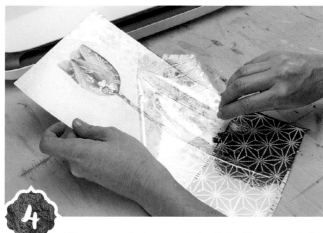

4 Allow to cool, then peel the foil off to reveal the patterned background.

Tips & Tricks

- Patchwork: If you don't have enough foil to cover your image, use multiple pieces of foil. Using different patterned foils together can create a unique patchwork look.

- When I paint the soft gloss gel around my images, I like to leave a white edge around the motif to create a halo effect.

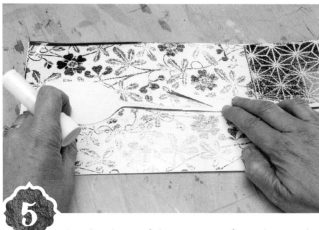

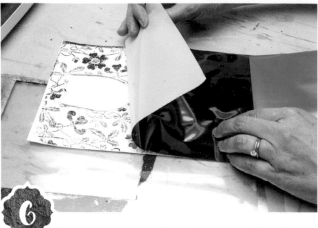

5 Cut the shape of the image out from the regular copy paper print and use it as a mask to cover the image on the watercolor paper. I cut a mask because I didn't want the turquoise foil to appear on the flower.

6 Place a contrasting foil color on top of the design, place it in the carrier and run it through the laminator again.

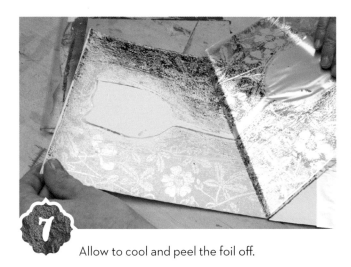

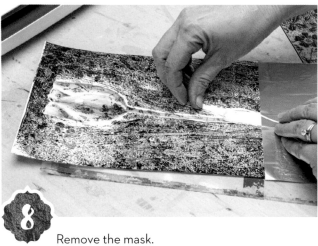

7 Allow to cool and peel the foil off.

8 Remove the mask.

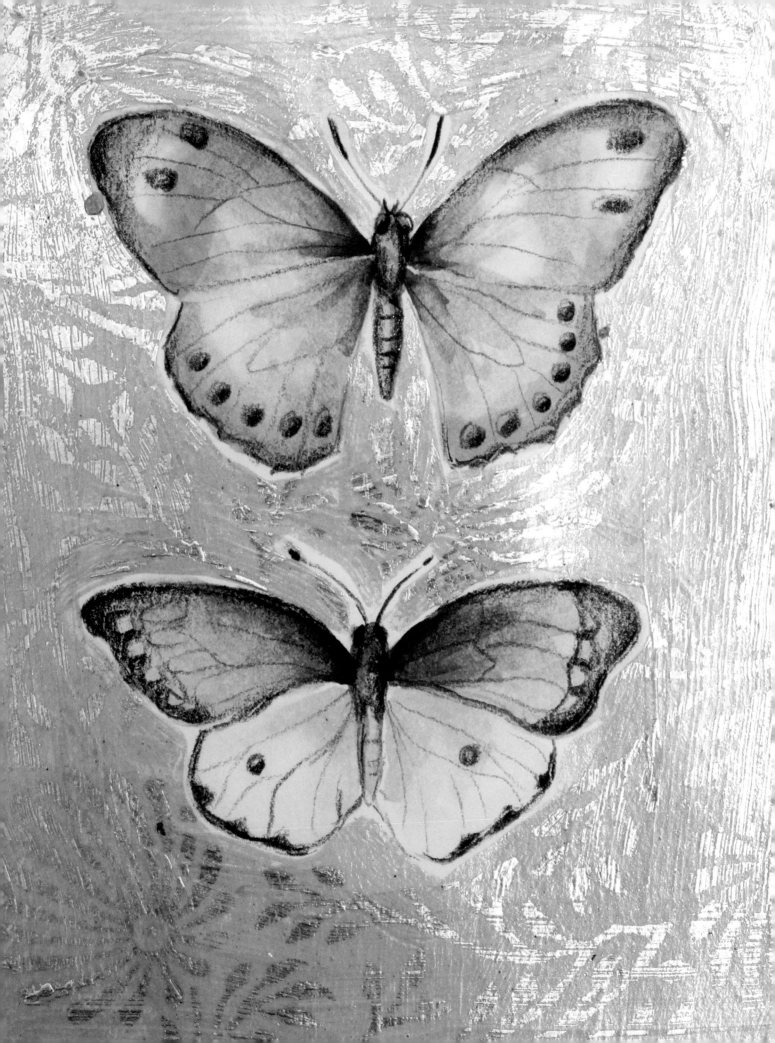

Gloss Gel with a Stencil

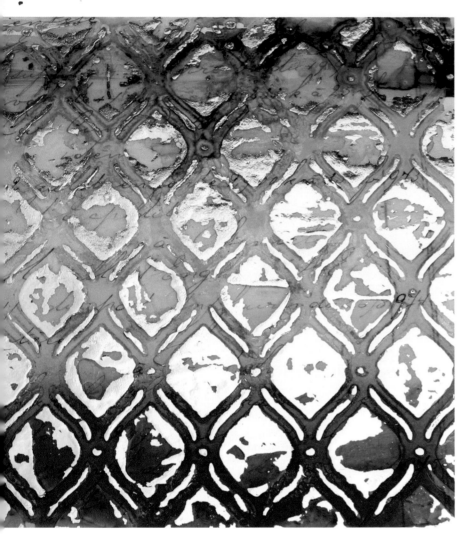

Creating raised textural patterns with gloss gel and stencils can add a dimensional quality to your mixed media. Gloss gel also creates a resist when watercolor is brushed on. The glossy surface is the perfect adhesive to add transfer foil using an iron or laminator.

WHAT YOU NEED

- 3D Gloss Gel (Prima Marketing)
- paintbrush
- palette
- pattern stencil
- spreader (old gift card or spackle knife)
- tacking iron and mouse pad
- transfer foil
- vintage ephemera
- water-soluble inks

Tips & Tricks

- Experiment with using an iron for a more distressed foil coverage and the laminator for a cleaner, more solid coverage.
- Try different substrates like scrapbook paper, watercolor paper or bristol paper.
- This technique is not meant to be perfect; it's meant to look distressed.

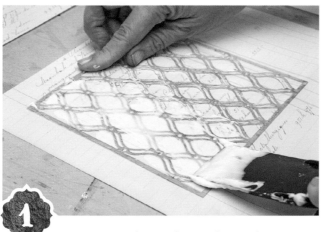

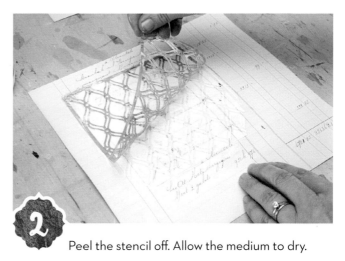

1 Using a spreader, apply 3D Gloss Gel over a pattern stencil placed on top of a piece of vintage ephemera.

2 Peel the stencil off. Allow the medium to dry.

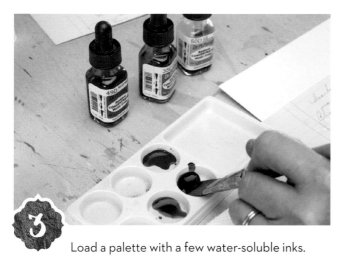

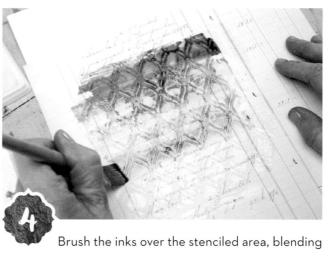

3 Load a palette with a few water-soluble inks.

4 Brush the inks over the stenciled area, blending softly between colors.

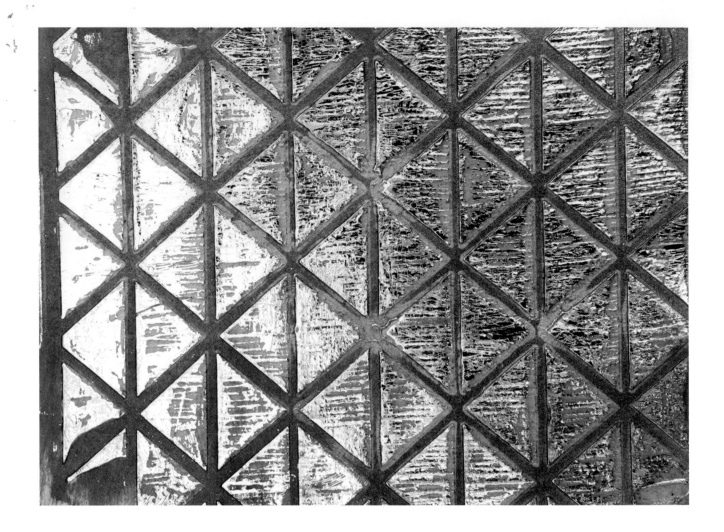

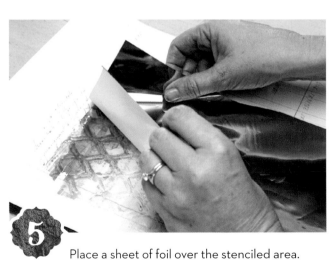

5 Place a sheet of foil over the stenciled area.

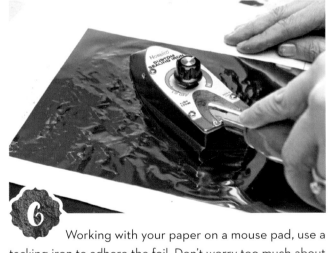

6 Working with your paper on a mouse pad, use a tacking iron to adhere the foil. Don't worry too much about covering every square inch.

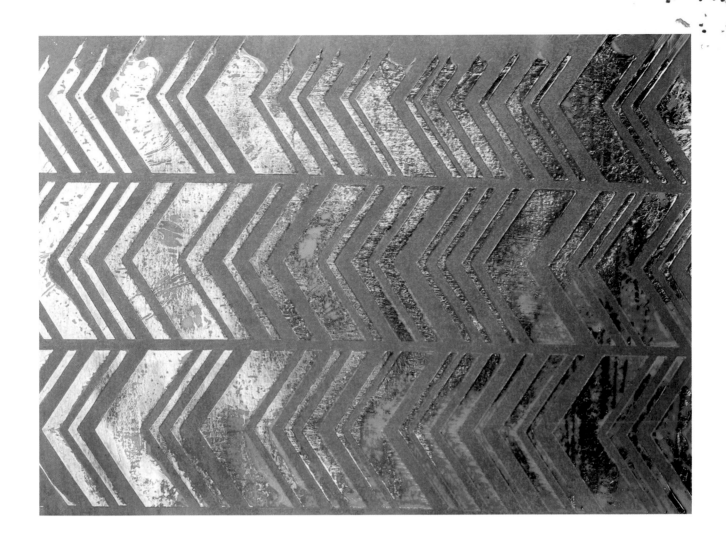

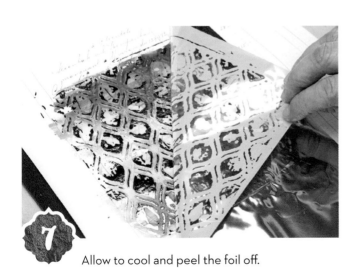

7 Allow to cool and peel the foil off.

Lace Resist

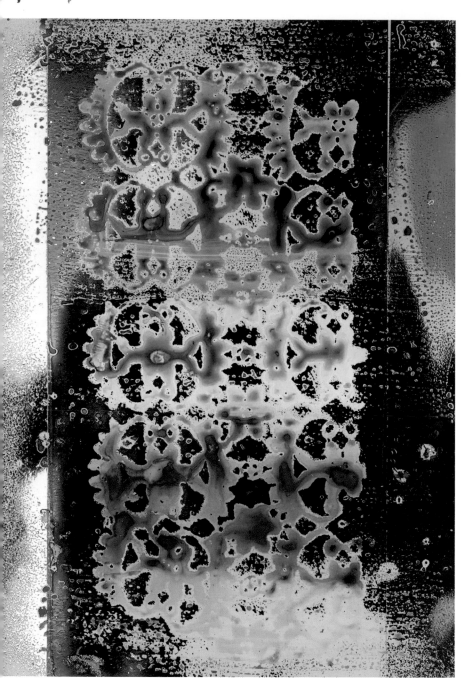

Most of my favorite techniques are discovered through experimentation. When I started working with transfer foils, I tried everything as an adhesive. I had done a class project with my high school students where we had coated a canvas with a clear spray gloss and I had several cans left over. I started spraying it through stencils to see if it would work as a resist and it worked great! I wondered if foil would stick to it since it was glossy. It did! For this demo, I used Yupo paper. Yupo paper is a nonabsorbent synthetic paper with an ultrasmooth surface that allows paints, watercolors and inks to sit right on top of the paper, giving it a watery effect.

WHAT YOU NEED

- lace
- laminator with carrier or tacking iron and mouse pad
- low-odor clear gloss spray (Krylon)
- paintbrush
- transfer foil
- water-soluble inks or watercolors
- Yupo paper

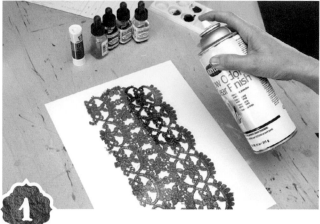

1 Place lace on a piece of Yupo paper and spray with clear gloss. Allow the medium to dry.

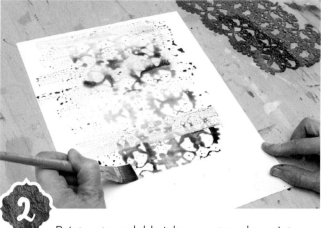

2 Paint water-soluble inks or watercolor paint over the paper. Allow to dry.

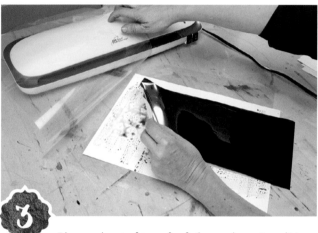

3 Place a sheet of transfer foil over the painted Yupo paper. Place in a carrier and run through a laminator or use a tacking iron to transfer the foil.

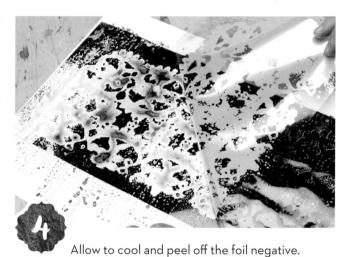

4 Allow to cool and peel off the foil negative.

Tips & Tricks

- For more of a full coverage of foil, use the laminator. For more distress, use the iron.

- Try an ombré approach with your inks or watercolor paints. Ombré describes the gradual blending of one color hue to another, usually moving tints and shades from light to dark.

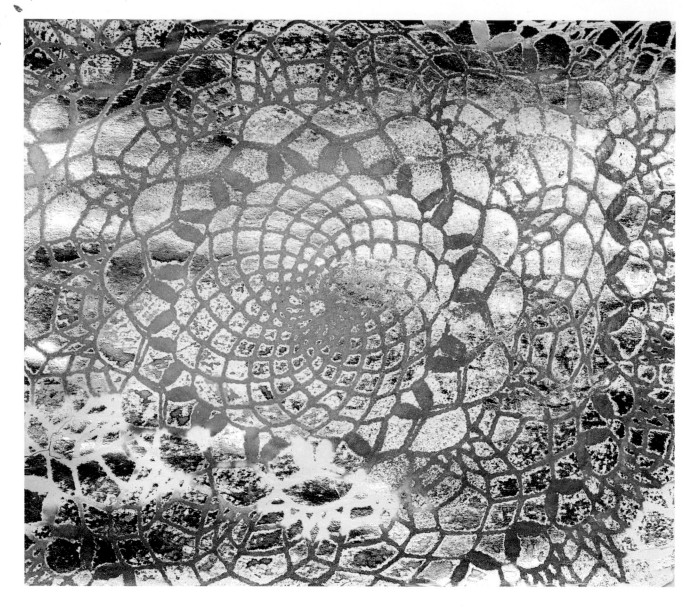

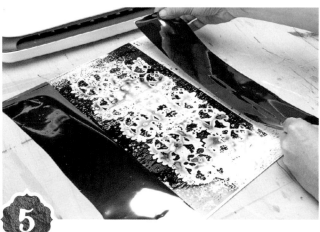

5 If your paper is larger than the foil sheet, use additional strips of foil to continue covering the Yupo paper, and run it through the laminator again, or use a tacking iron to transfer the foil.

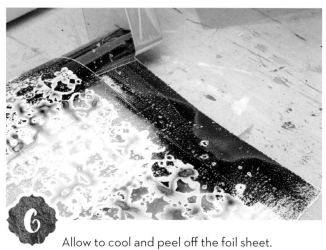

6 Allow to cool and peel off the foil sheet.

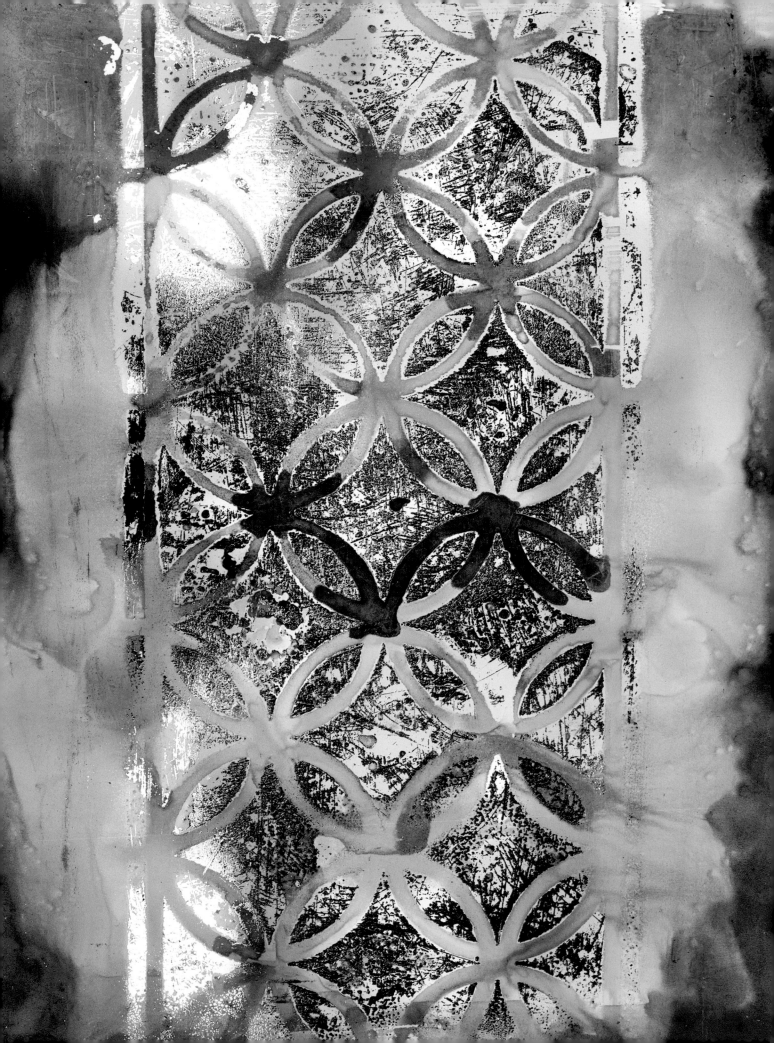

Fabric Fusible Spray on Wood

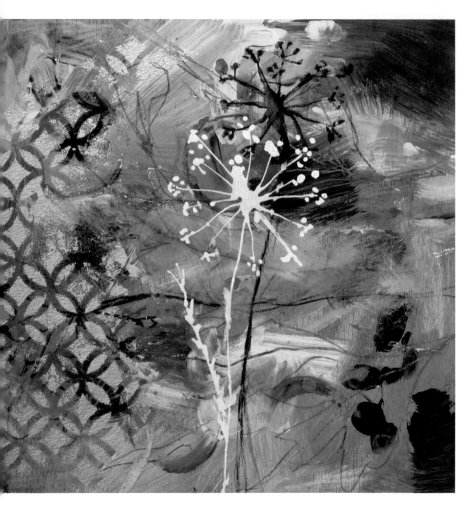

Deco Foil fusible spray adhesive is a permanent adhesive that let's you add transfer foil onto fabric. I wanted to experiment with the spray on wood, so I used an existing acrylic abstract painting to apply the fusible spray.

WHAT YOU NEED

- craft iron
- painted wood panel
- spray adhesive (Deco Foil fusible spray adhesive)
- stencil
- transfer foil

Tips & Tricks

- Expect surprises! This technique is an awesome way to apply transfer foil to fabric, canvas, paper and wood, but it can have a mind of its own. Go with the flow and allow it to surprise you.
- Make sure to shake the can well before using.

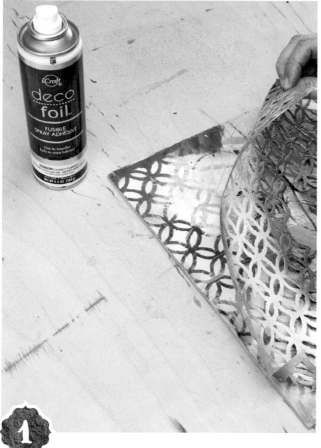

1 Place a stencil on a previously painted panel and spray through the stencil with adhesive. Lift off the stencil. Allow the adhesive to set.

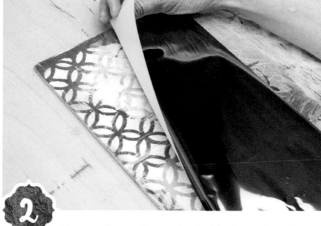

2 Place a sheet of transfer foil (color-side up) over the sprayed area.

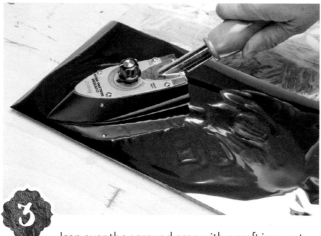

3 Iron over the sprayed area with a craft iron, set on medium heat.

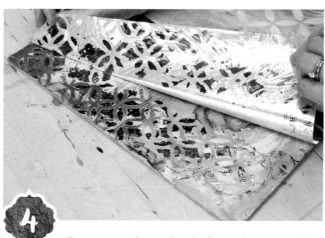

4 Allow it to cool completely (for 1–2 hours). Peel off the foil to reveal.

Foil Glue

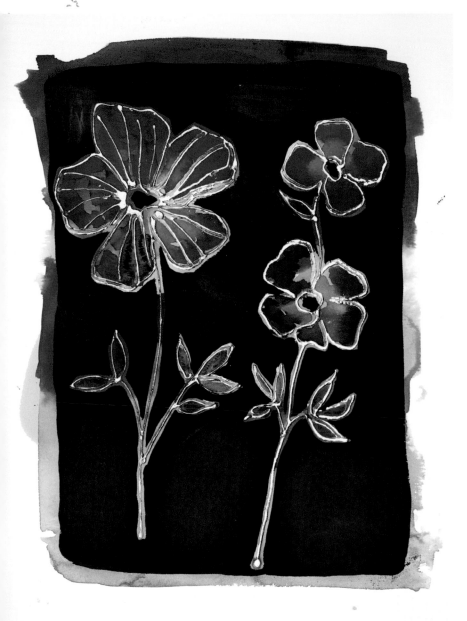

Foil transfer glues are great because they don't require any heat but are instead pressure sensitive. When the glue dries it remains tacky to the touch, and the transfer foil can be applied directly to the adhesive with pressure from your fingers. The glues come in a variety of brands and also different applicators. The glues give a dimensional look when drawn using an applicator or they can be brushed on with a foam brush.

WHAT YOU NEED

- foil transfer adhesive (Deco Art)
- gouache (black)
- paintbrushes
- paper towel
- transfer foil
- watercolor paper
- watercolors, small pan set (optional)
- watercolors, concentrated liquid (Dr. Ph. Martin's)

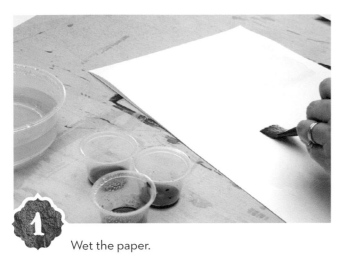

1 Wet the paper.

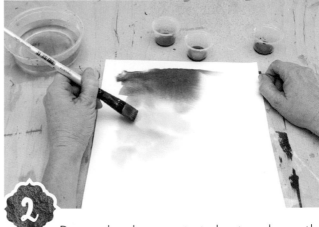

2 Drop or brush concentrated watercolor on the paper to create a blended wash. Allow to dry.

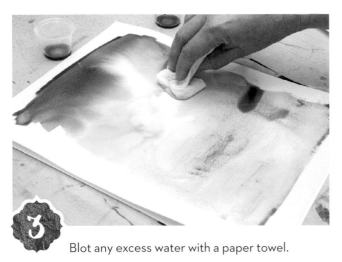

3 Blot any excess water with a paper towel.

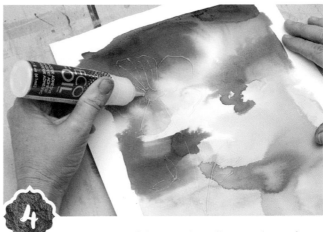

4 Using the tip of the transfer adhesive, draw a large flower with a leaf and small bud. Draw a second small flower if the composition needs it.

Tips & Tricks

- I am using a wet-on-wet technique to apply watercolor here. I wet the paper to make it accept the watercolor readily.

- Concentrated watercolors are just that: concentrated. A little goes a long way, and you can dilute the paint with water for a lighter hue. They come with an eyedropper applicator, and it's fun to drop the color directly on the wet paper and allow the colors to blend together. Sometimes I add some sprinkles of salt to the wet watercolors to create a crystallized pattern.

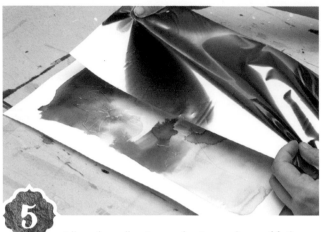

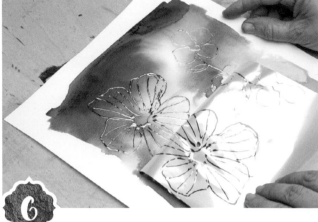

5 Allow the adhesive to dry. Lay a sheet of foil over the adhesive (shiny- or color-side up).

6 Using your fingers, apply light pressure over the areas with adhesive. Gently peel up the foil sheet.

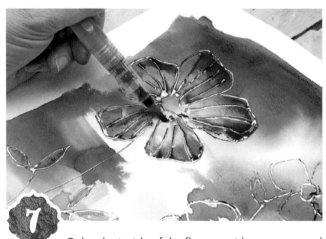

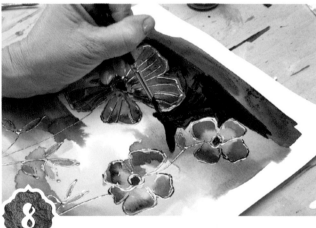

7 Color the inside of the flowers with concentrated watercolors using a water brush or paintbrush.

8 Mix a small amount of black gouache with water so it's the consistency of melted ice cream. (If the gouache is too thick it will be difficult to paint; if it's too thin it will be too transparent.) Paint black gouache in the background around the flower shapes.

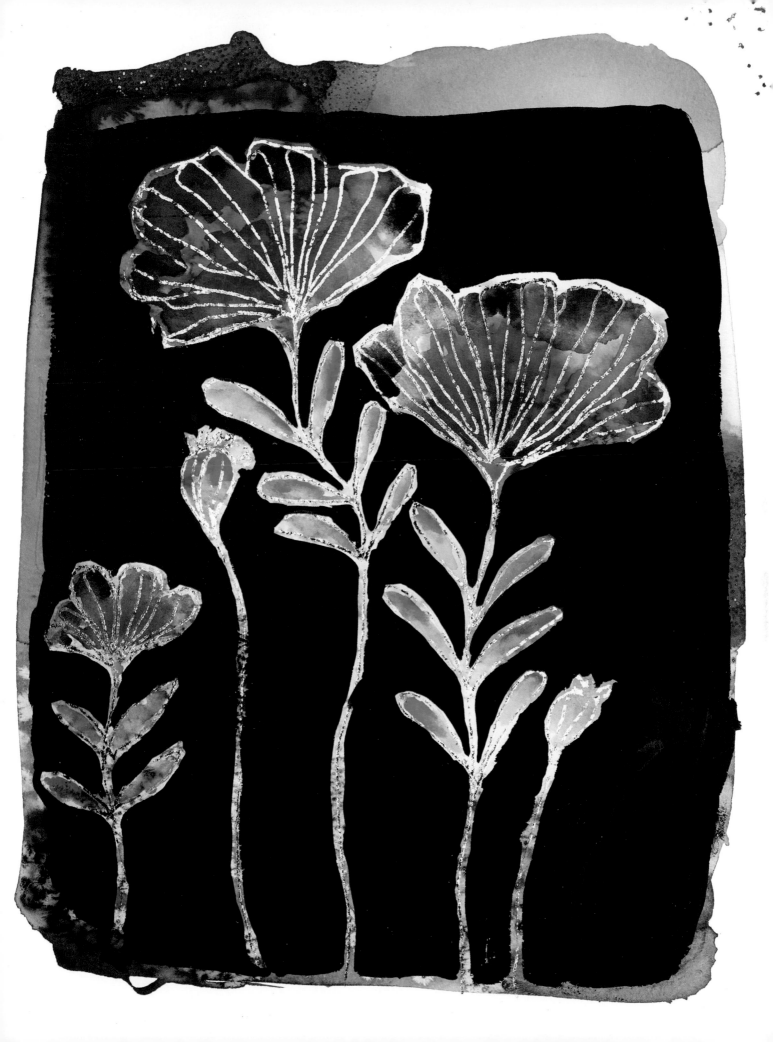

Foil Glue Pen

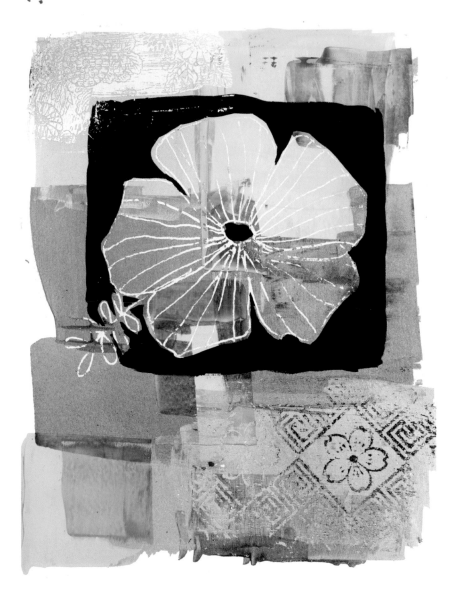

The foil glue pen comes in several forms. My favorite one is similar to a ballpoint pen, which has a thin line. Some pens have a thicker line quality and are similar to a felt-tip pen. These pens require no heat. You simply draw with the glue pen and once the glue dries and is tacky to the touch, apply foil over what you drew.

WHAT YOU NEED

- acrylic paints (metallics)
- craft iron
- glue pen (Sakura Quickie)
- gouache (black)
- negative foil
- paintbrushes
- paper palette
- soft gloss gel (Prima Marketing)
- spreader (old credit card)
- transfer foil
- watercolor paper or bristol paper

1 Choose four to five harmonious acrylic colors. Squeeze a bit of paint onto a paper palette. Dip a credit card into one color and scrape it onto the paper, creating a block of color. Repeat with other colors over the surface of the paper, creating a patchwork pattern. Allow to dry.

2 Using a Quickie glue pen, draw simple flower shapes over the color-blocked ground. Allow to dry. (When dry, the glue will still be tacky but not wet.)

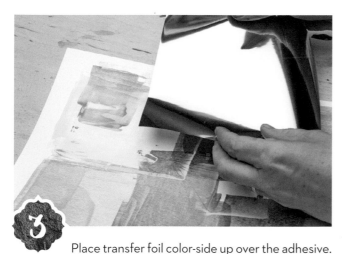

3 Place transfer foil color-side up over the adhesive.

4 Burnish over the adhesive with your fingers or use the credit card to burnish.

Tips & Tricks

- Embellish additionally with gel pens.

- I teach children's art classes in my studio. Most of the time the kids squeeze too much paint onto their palettes, and I'm left with a lot of leftover paint. I never like to waste precious resources, and I have a sketchbook filled with heavy watercolor paper. So after a class, I grab some paint scrapers (old gift cards/hotel room keys), and I color block the paint into my sketchbook. That way I have backgrounds all ready to go and never have to combat a blank white page.

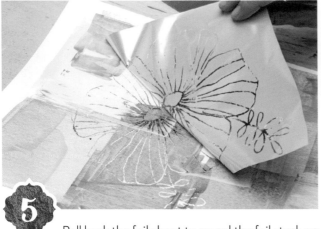

5 Pull back the foil sheet to reveal the foil stuck on the glue. If you find any areas are still tacky, continue to put foil down until the glue is covered completely.

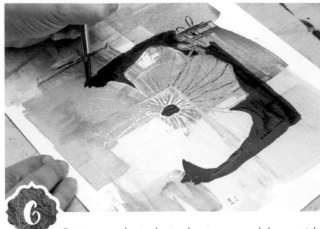

6 Paint gouache in desired areas around the outside of the flower(s). The black gouache is meant to make the flower pop out; you don't need a lot.

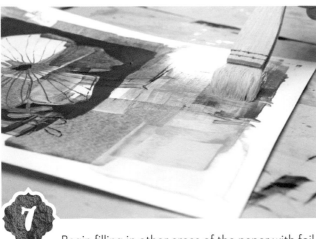

7 Begin filling in other areas of the paper with foil. One way to do this is to first apply soft gel over an area and allow to dry.

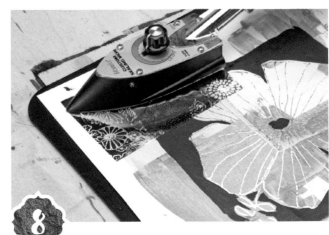

8 Lay a negative foil that you've used previously over the gel area. Iron over the negative with a craft iron.

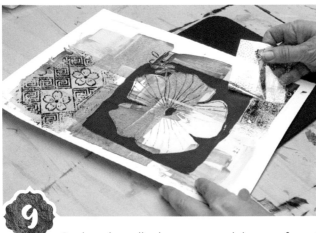

9 Peel up the cellophane to reveal the transferred negative foil.

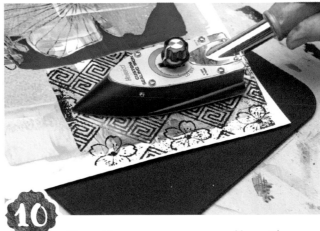

10 Repeat in as many areas as you like until you are satisfied with the entire page.

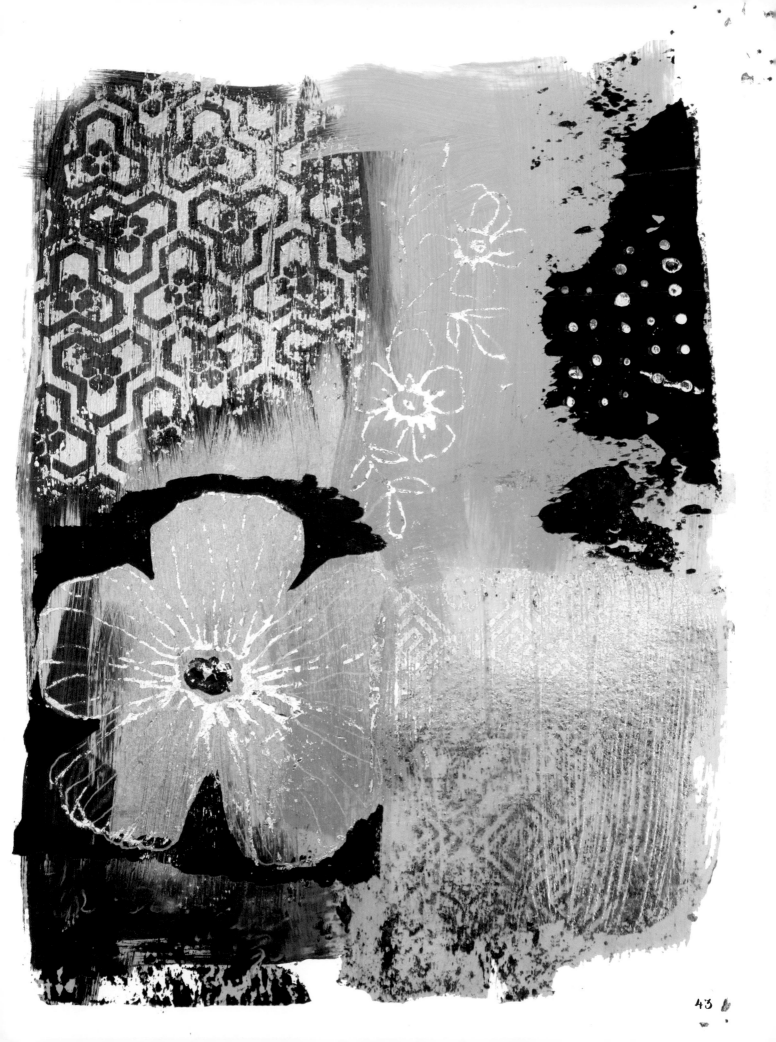

43

Glue Pen Over Bleach

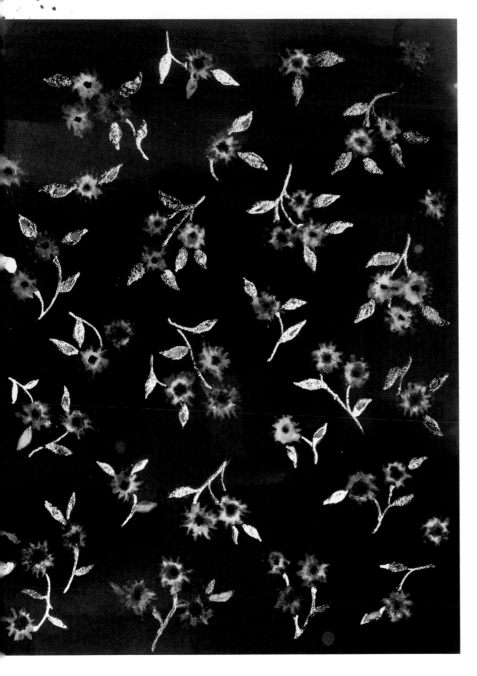

I was introduced to this bleach technique when I worked as a textile print designer. It was an effective way to emulate the discharge printing process that was popular at the time. We used Dr. Ph. Martin's concentrated watercolors because of their brilliant hues and because they are dye-based (unlike traditional watercolors) and react well to bleach. (Because they are dye-based, they are not as lightfast as pigment-based paints.) These paints are perfect for art journals, scrapbooks and designs that will be scanned but not hung on the wall.

WHAT YOU NEED

- bleach and glass jar
- glue pen (Sakura Quickie)
- gouache (black)
- paintbrush with nylon bristles
- spreader
- transfer foil
- watercolor paper or bristol paper
- watercolors, small pan set (optional)
- watercolors, concentrated liquid (Dr. Ph. Martin's)

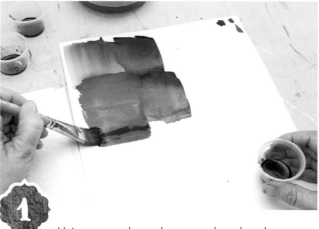

1. Using a couple analogous colors, brush concentrated watercolor onto paper in a patchwork fashion to create the background. Allow to dry.

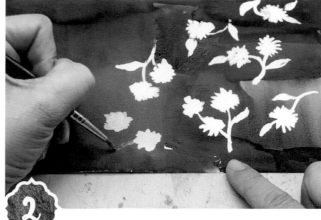

2. Once dry, pour a little bleach into a glass jar. Use a nylon brush to paint areas that you want to bleach or "discharge" color from the background.

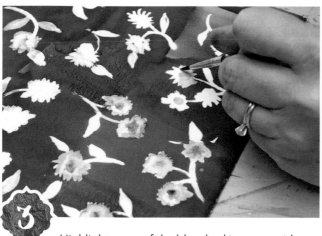

3. Highlight areas of the bleached imagery with pan watercolors. Allow to dry.

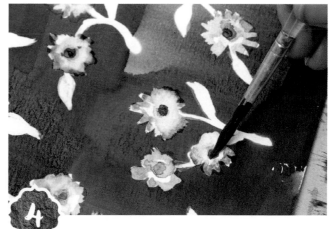

4. Add a bit of black gouache thinned with water for a bit of detail, such as the centers of flowers, or add shading.

Tips & Tricks

- When using bleach, you can dilute it to create different values or strengths. If you want to bleach to pure white, use full strength.

- Don't use a natural-hair brush because the bleach will eat away at it. Instead, choose an inexpensive synthetic brush.

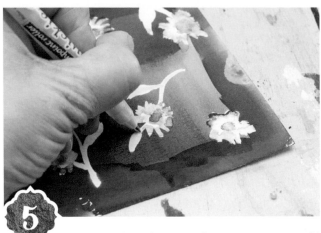

5 Use a Quickie glue pen where you want to add foil. Here, I'm applying it to the flower stems and leaves.

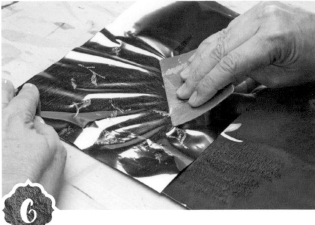

6 Place the foil color-side up over the glued areas and burnish until it releases onto the adhesive.

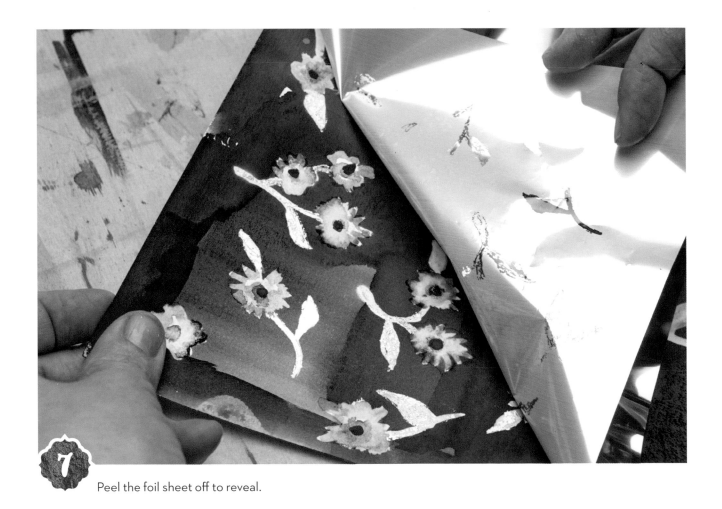

7 Peel the foil sheet off to reveal.

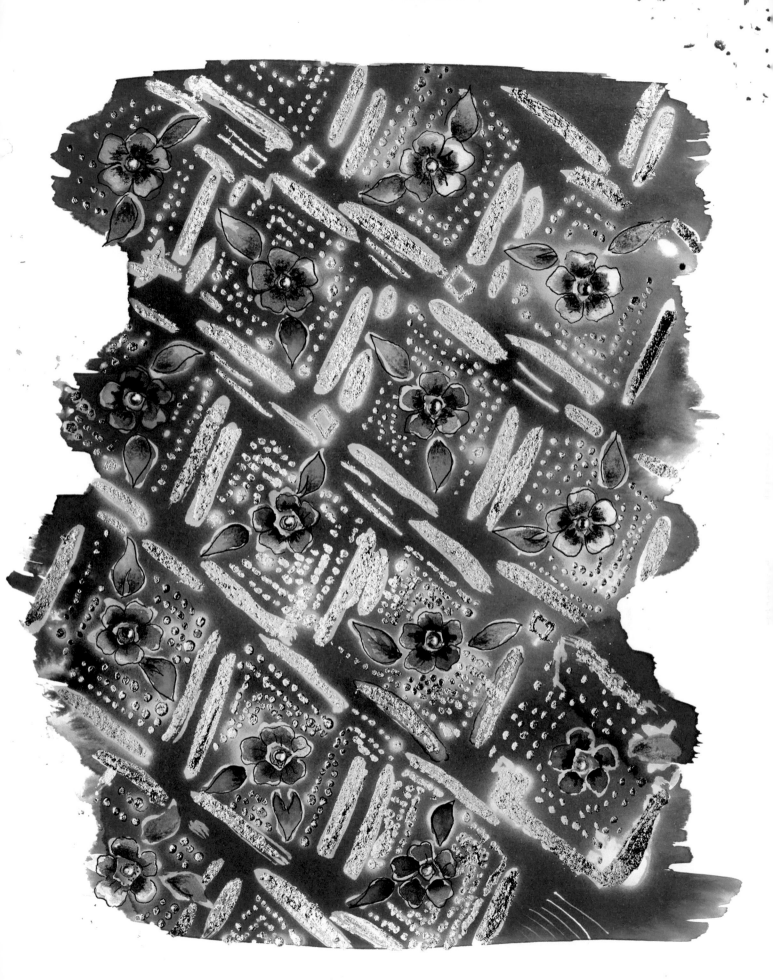

47

Sticky Embossing Powder

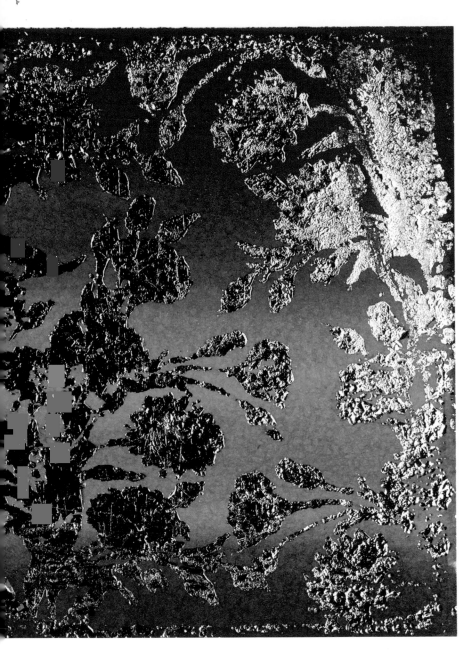

Stamping with foil glue is tricky, and with a lot of trial and error and some ruined stamps, I discovered that sticky embossing powder is the best approach to adding foil to your stamp images. Although the sticky embossing powder is designed to not need heat to fuse, I find it works best when an iron is used to fuse the foil to the sticky embossing powder.

WHAT YOU NEED

- clear embossing ink
- craft iron
- heat gun
- paintbrush
- painter's tape
- pan watercolor paints
- rubber stamp
- sticky embossing powder
- transfer foil
- watercolor paper

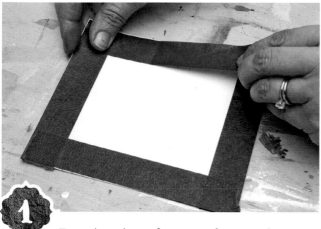

1 Tape the edges of a piece of watercolor paper with painter's tape.

2 Brush wet watercolor onto the dry surface, creating multiple layers of colors in a rainbow-like effect.

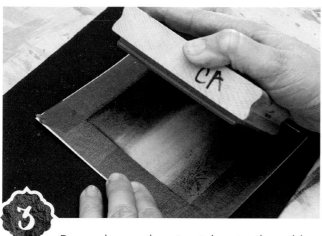

3 Press clear embossing ink onto the rubber stamp, then apply the stamp to the surface of the paper and remove it.

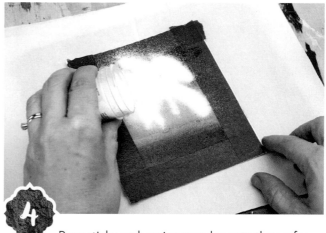

4 Pour sticky embossing powder onto the surface.

Tips & Tricks

- As an alternative to sticky embossing powder you can use a glue stamp pad to apply the transfer foil.

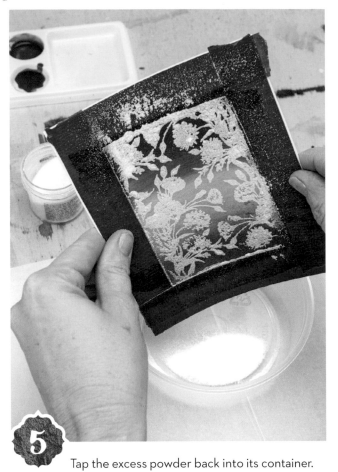

5 Tap the excess powder back into its container.

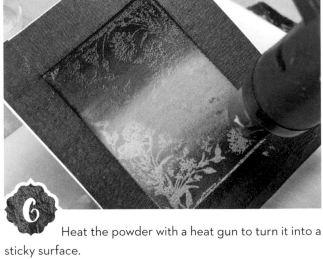

6 Heat the powder with a heat gun to turn it into a sticky surface.

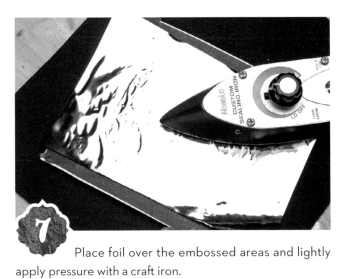

7 Place foil over the embossed areas and lightly apply pressure with a craft iron.

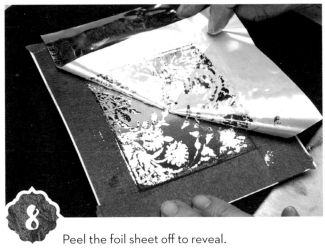

8 Peel the foil sheet off to reveal.

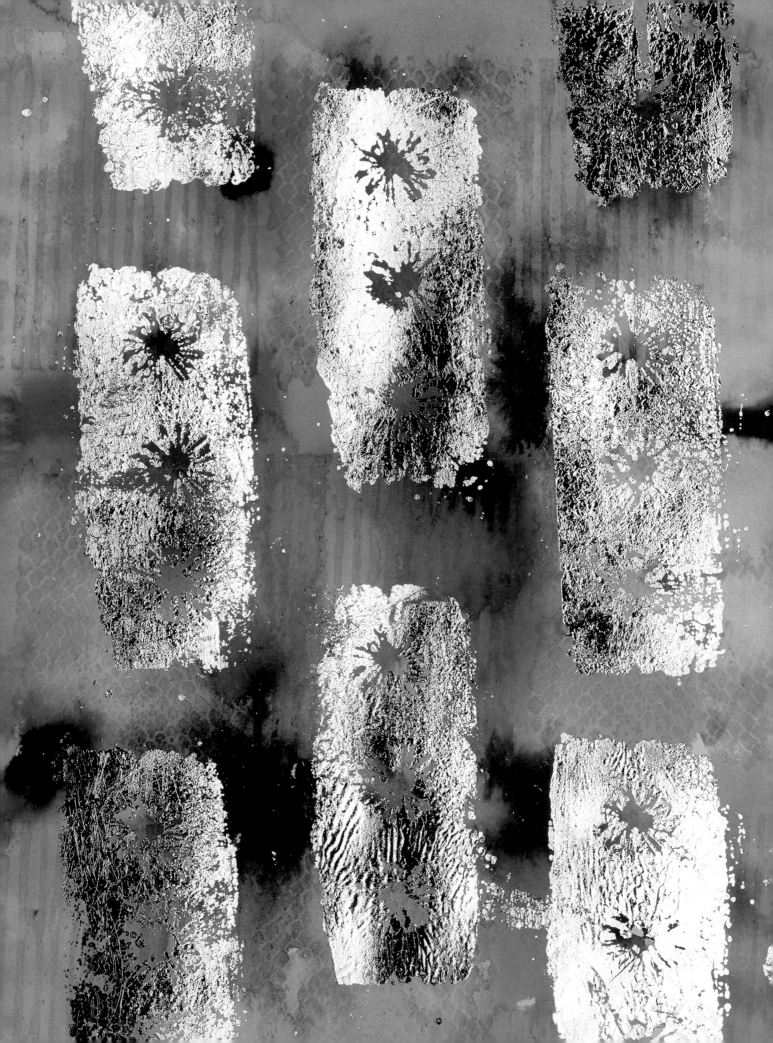

Foil Rub-Ons on Wood

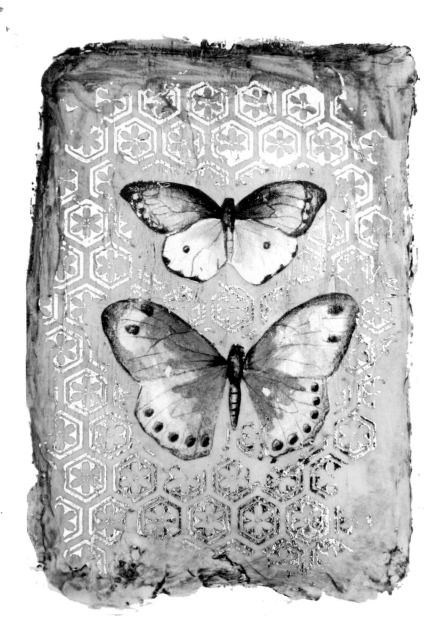

Adhesive rub-ons offer, by far, the most effortless way to add foil to your projects. You can find designs that are patterns, icons and words to add foil to your mixed-media art, cards and scrapbook pages. The rub-ons come sticky and do not need heat. You simply adhere the rub-on to your surface and apply transfer foil. These adhesive rub-on sheets can be used with glitter and mica as well.

WHAT YOU NEED

- adhesive rub-ons (Christine Adolph, Prima Marketing)
- collage icons (two butterflies)
- glue
- molding paste
- paintbrush
- scissors
- spackle knife or old credit card
- transfer foil
- watercolor paper
- water-soluble oil pastels (Iron Orchid Designs, Prima Marketing)
- wood panel

Tips & Tricks

- The rub-ons work beautifully on glass, metal, candles and even photographs.
- Reserve the negative foil images and use with adhesive sheets to create a bookmark or gift tag.

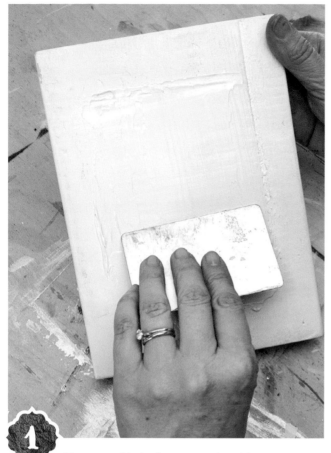

1 Use a spackle knife to spread molding paste over a wood panel. Allow to dry.

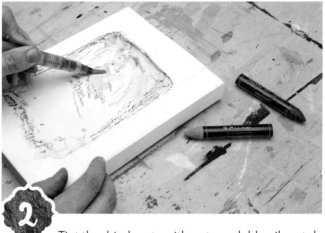

2 Tint the dried paste with water-soluble oil pastels and brush water over the surface to create a wash background. Let it dry.

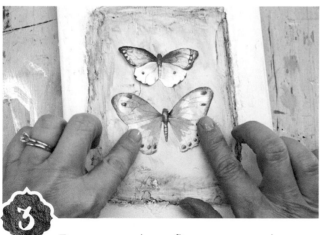

3 Trace your two butterflies onto watercolor paper and cut them out. Set the watercolor shapes aside and glue the butterfly images onto the background.

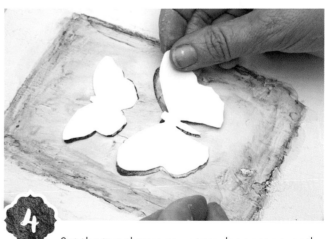

4 Set the two shapes on watercolor paper over the glued-down butterflies to act as a mask.

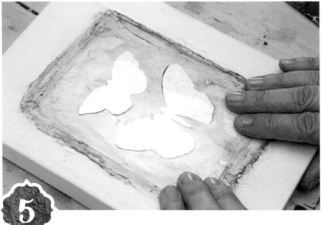

5 Pull the protective back sheet off the rub-on and apply it to the painting.

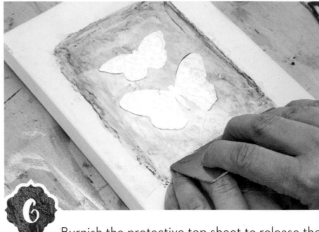

6 Burnish the protective top sheet to release the rub-on to the surface of the painting.

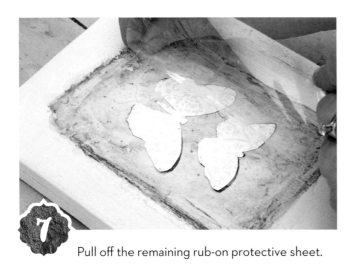

7 Pull off the remaining rub-on protective sheet.

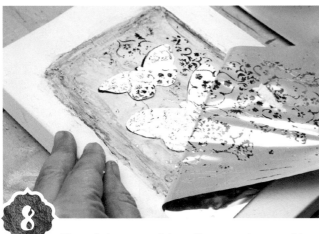

8 Place foil on top of the adhesive rub-on and burnish. Pull the cellophane top layer off. Take the masked butterflies off and save to use later.

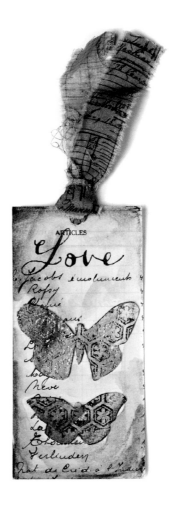

I used the butterfly watercolor mask to create this bookmark. I added foil and colored it with water-soluble oil pastels and glued it onto a vintage piece of ephemera.

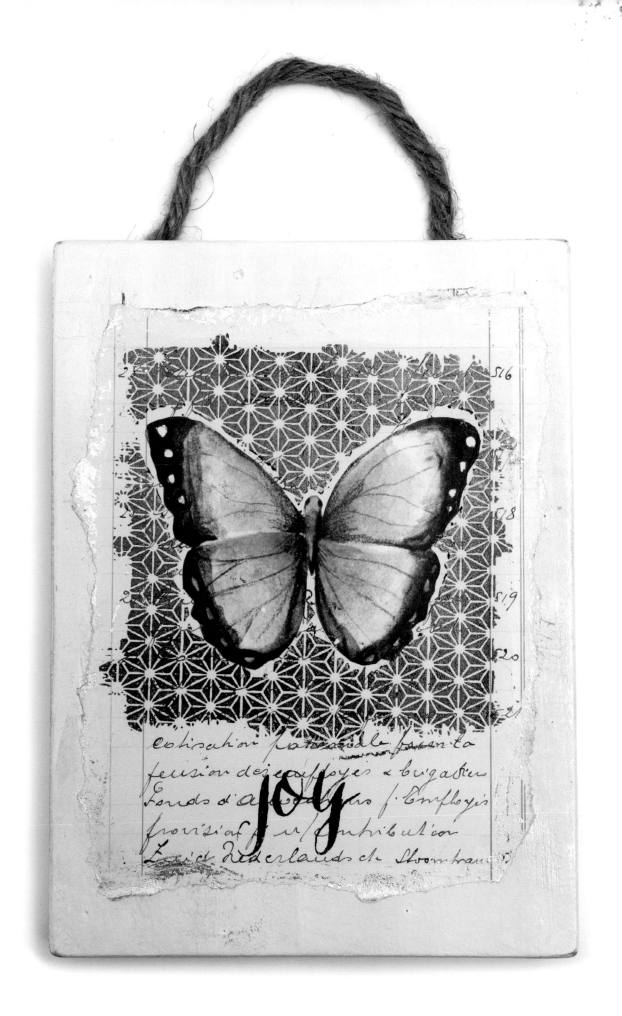

Foil Rub-Ons on Ephemera

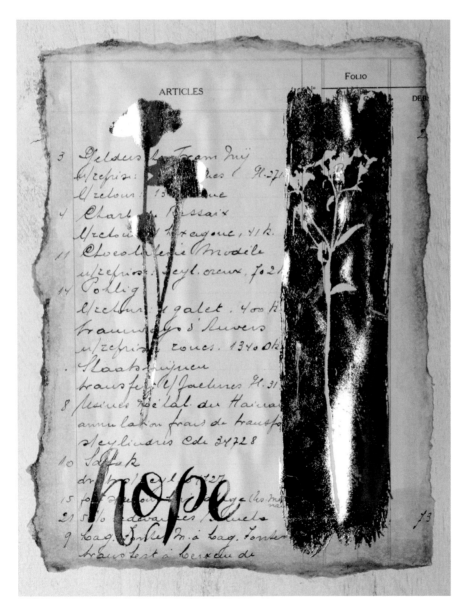

This is a quick home décor piece. The rub-ons provide a fast process for creating a piece of art, literally in minutes. There is no waiting for glue to dry or heating up irons or laminators. I used a premade vintage-inspired wall base, but you don't have to do this. You can repurpose a found object like an old piece of barn wood or a vintage wood tray.

WHAT YOU NEED

- adhesive rub-ons (Prima Marketing)
- Carte Blanche Vintage Wall Décor Base (Prima Marketing)
- glue
- scissors
- transfer foil
- vintage ephemera
- water brush
- water-soluble oil pastels

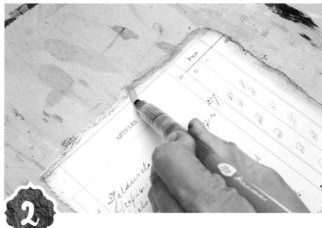

1 Distress the edges of the ephemera with water-soluble oil pastel.

2 Go over the pastel with a water brush to blend the colors out. Let it dry.

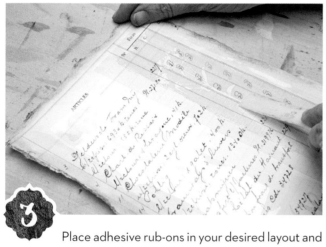

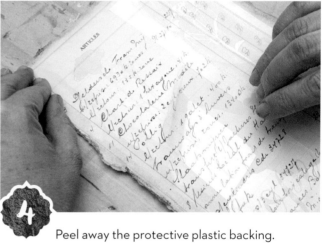

3 Place adhesive rub-ons in your desired layout and burnish with the craft stick that comes with the rub-ons.

4 Peel away the protective plastic backing.

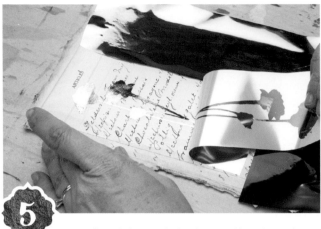

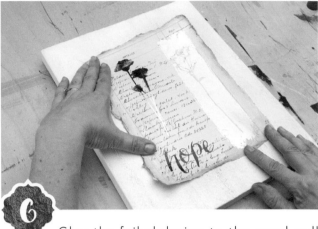

5 Cut a few different foil colors and lay them down, color-side up, onto the adhesive. Burnish over the foil so that it adheres to the rub-on. Peel away the foil to reveal the image.

6 Glue the foiled design to the wood wall décor base.

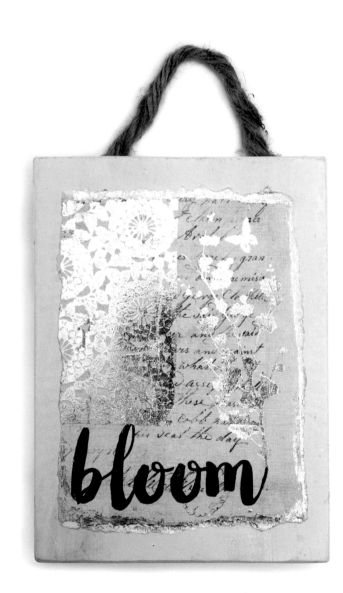

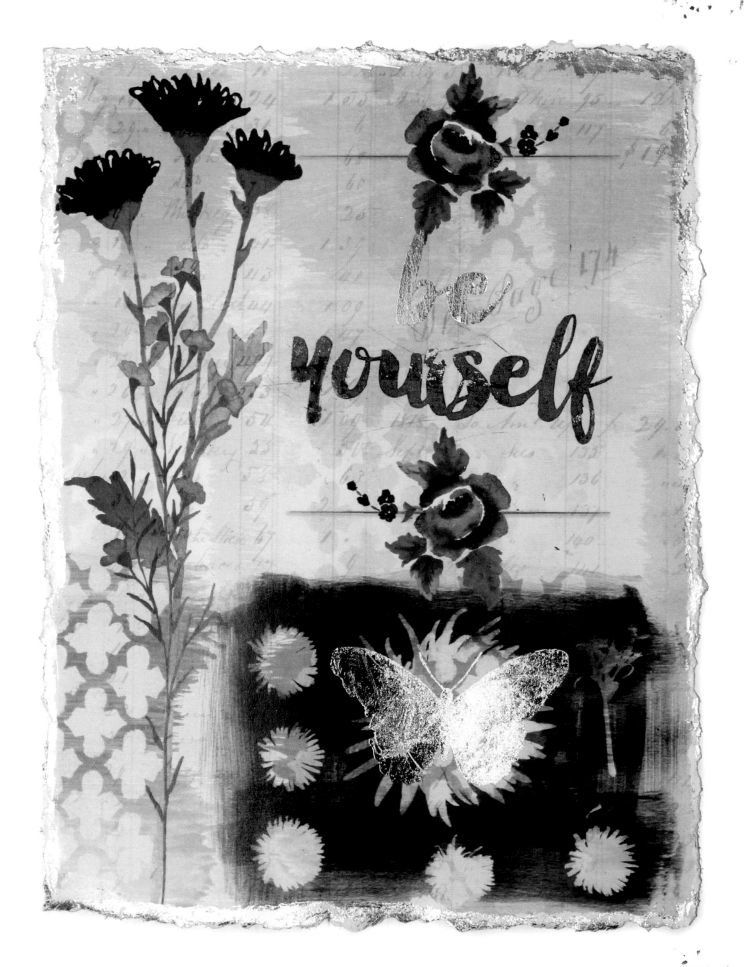

be
yourself

Adhesive Sheet Bookmark

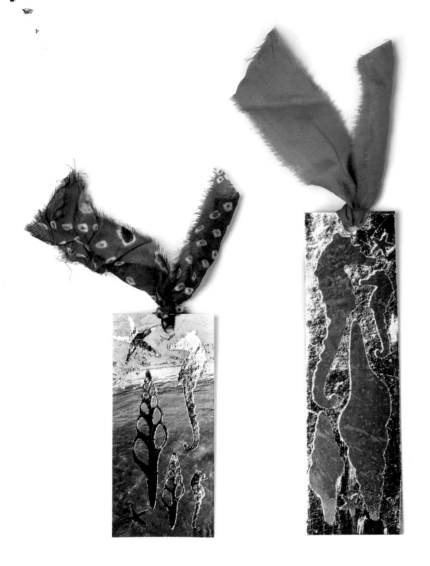

Adhesive sheets offer a no-heat, easy way to adhere foil to your projects without messy glues or drying time. The sheets can be die-cut or punched, and they can also be used to adhere some of the pretty foil negatives that get generated in the process of working with the foils.

WHAT YOU NEED

- adhesive sheet (iCraft Easy Cut)
- die-cut machine or hand punches
- magazine pages
- scissors
- transfer foil

Tips & Tricks

- Browse through old magazines for landscapes that are relevant to what you're doing. Here I recycled old surf magazines since I wanted to incorporate a seahorse image and needed a fitting background.

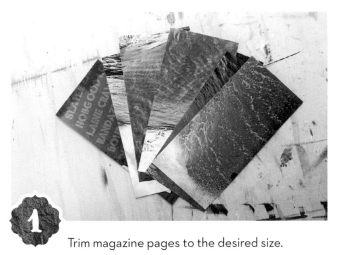

1 Trim magazine pages to the desired size.

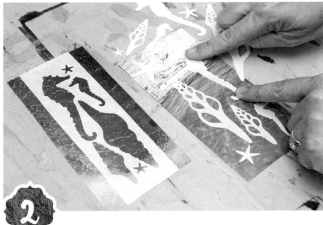

2 Die cut or punch designs out of the adhesive sheet. Peel off one side of the sheet and adhere the sticky side to the magazine pages. Feel free to use the negative part of the sheet as well as the punched imagery.

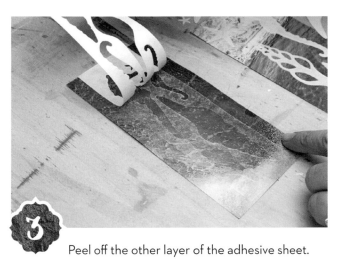

3 Peel off the other layer of the adhesive sheet.

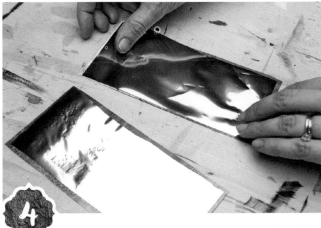

4 Apply the transfer foil (color-side up) to the adhesive and burnish using your fingers.

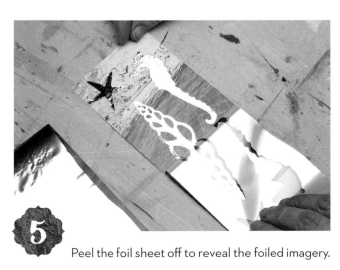

5 Peel the foil sheet off to reveal the foiled imagery.

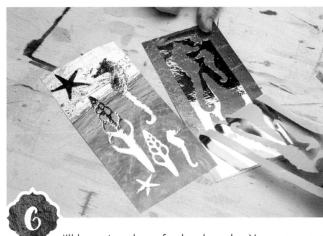

6 I'll be using these for bookmarks. You may want to trim your pieces further at this point or leave them as they are.

Adhesive Sheet Card

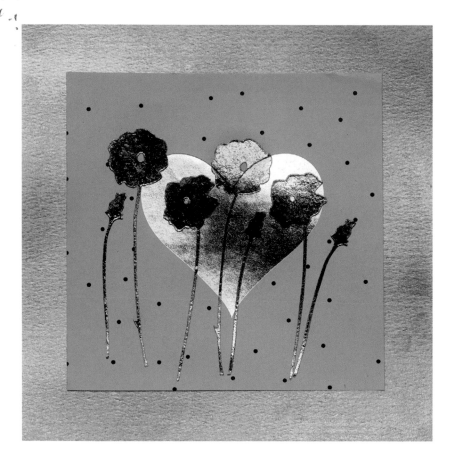

If you prefer your foil to be cleanly adhered and you don't like the distressed look that other techniques give, adhesive sheets are a perfect method for you. They are easy to layer onto scrapbook paper and are great for a quick card project. Adhesive sheets are ideal for your foil negative, too.

WHAT YOU NEED

- acrylic paint (Interference Gold)
- adhesive sheet (iCraft Easy Cut)
- die-cut machine or hand punches
- glue
- old credit card or scraping tool
- scrapbook paper
- transfer foil
- watercolor paper or bristol paper

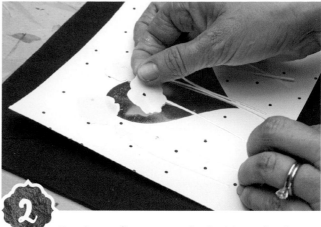

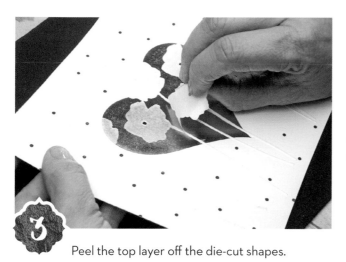

1 Paint one piece of watercolor paper with Interference Gold by scraping the paint onto the surface with an old credit card or other scraping tool.

2 Cut die-cut flowers out of a double-stick adhesive sheet. Peel the backing off the shapes and adhere them to a piece of scrapbook paper. (The one I'm using already had a gold heart in the center.)

3 Peel the top layer off the die-cut shapes.

4 Apply the transfer foil (color-side up) to the adhesive and burnish using your fingers.

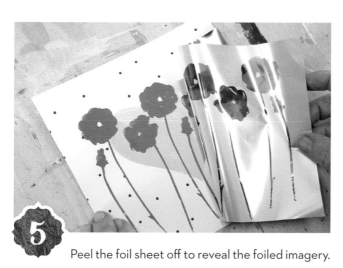

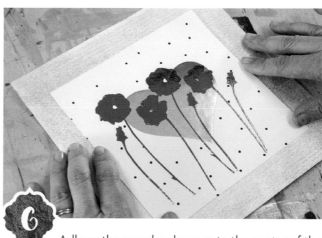

5 Peel the foil sheet off to reveal the foiled imagery.

6 Adhere the scrapbook paper to the center of the painted paper to complete.

Foil on Fabric

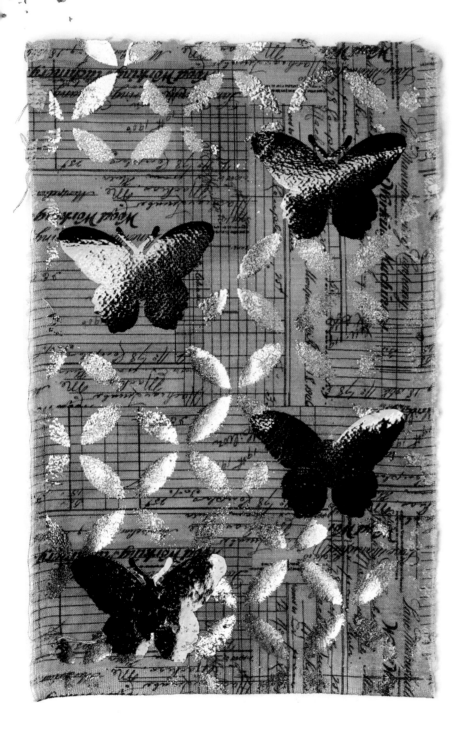

There are several ways to add the sparkle of foil to your quilts, wall hangings, home décor pieces or wearable art. This demo will show you two ways. First we will use fusible spray adhesive with stencils. Next we will create a butterfly pattern using a Hot Melt sheet that I die cut. These small fabric samples can be used to glue onto altered books or used as a patch in a wall hanging or quilt.

WHAT YOU NEED

- adhesive sheets (Deco Foil Hot Melt)
- butterfly (die-cut or punch shape)
- cotton fabric
- fusible spray adhesive (Deco Foil)
- laminator or craft iron
- stencil
- transfer foil (two colors)

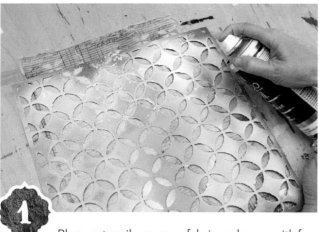

1 Place a stencil over your fabric and spray with fusible spray adhesive. Allow to dry for at least ten minutes. Preheat the laminator (or craft iron).

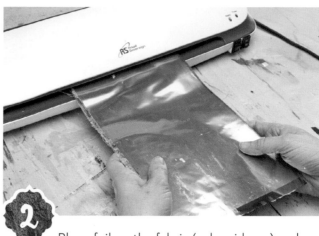

2 Place foil on the fabric (color-side up) and run through the laminator. Allow to cool for an hour.

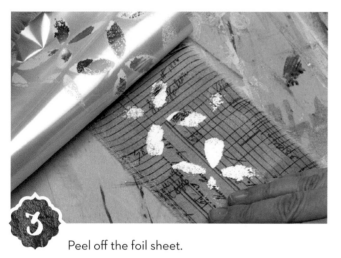

3 Peel off the foil sheet.

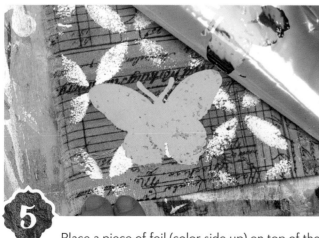

4 Punch a butterfly from a sheet of Hot Melt and adhere it to the fabric with an iron or run it through the laminator. Once cooled, peel off the top layer.

5 Place a piece of foil (color-side up) on top of the adhesive butterfly and run it through the laminator. Allow to cool and peel the foil to reveal the sparkly butterfly.

Tips & Tricks

- Make sure you shake the fusible spray adhesive well before use.

- You can use your iron for fusing foil to the Hot Melt sheets if you prefer.

- Washing instructions for fabric: Hand wash and lay flat to dry. If needed, machine wash on cold, delicate cycle. Do not iron.

Glue Stick

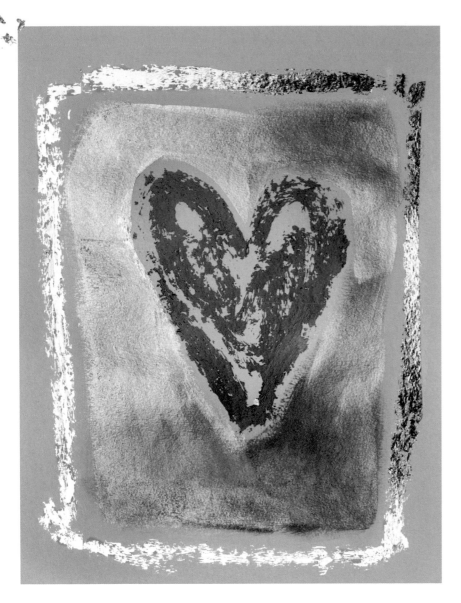

Glue stick is an effective no-heat way to add foil to your cards and craft projects. Glue sticks are easy to come by, and this by far is the most accessible foil technique that's perfect for children and beginners. The foil will release in a more textured way. It is a perfect technique for adding a metallic edging to any paper-crafting project.

WHAT YOU NEED

- acrylic paint (shimmering colors)
- bristol paper
- glue stick
- paintbrush
- transfer foil (two colors)

1 Use a glue stick to draw a heart shape onto a piece of bristol paper. Also draw a loose border with the glue.

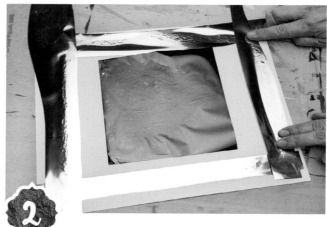

2 Before the glue dries, apply transfer foil to the glued areas. Press down firmly to adhere, then leave as is to dry.

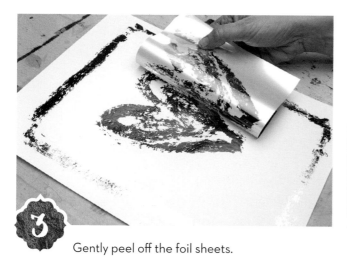

3 Gently peel off the foil sheets.

4 Apply shimmering acrylics to the white areas of the paper.

Tips & Tricks

- You don't have to use the glue stick freehand. If you have a specific image you like, cover a piece of scrapbook paper with a stencil of your choice. Apply glue through the stencil as you would paint. When finished, remove the stencil.

- The longer you leave the foil on to dry with the glue, the more foil will adhere to the paper.

Adhesive Dots and Stripes

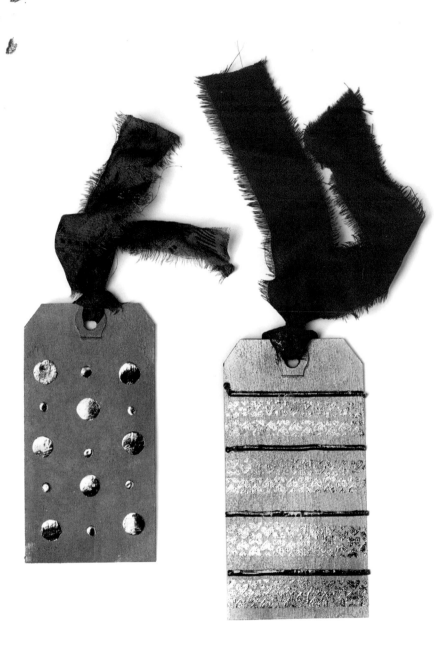

Tape runners come in the most fun patterns now. I've seen them in hearts, dots and geometrics. They are a great vehicle to add metallic stripes and patterns on tags and cards. The adhesive dots come in a variety of scales and are an easy way to create a polka-dot background.

WHAT YOU NEED

- burnishing tool
- heart-patterned tape runner
- prepainted tags
- transfer foil
- Zips Clear Adhesive Lines (Therm O Web)
- Zots Clear Adhesive Dots (Therm O Web)

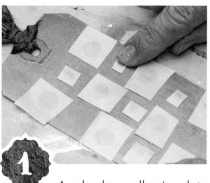

1 Apply clear adhesive dots to the surface of a prepainted tag or bookmark. Use various sizes of dots in different patterns on the tag.

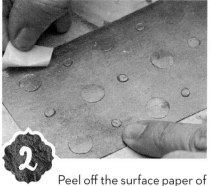

2 Peel off the surface paper of the adhesive dots.

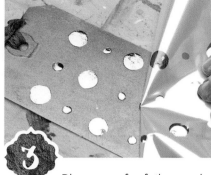

3 Place transfer foil onto the surface of the tag and rub the foil against the adhesive dots, burnishing the foil with your thumb. Peel up the foil sheet.

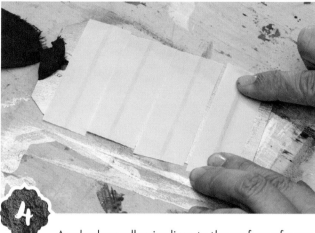

4 Apply clear adhesive lines to the surface of a prepainted tag or bookmark.

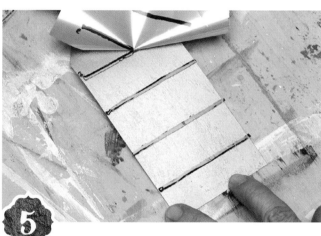

5 Peel off the surface paper of the adhesive lines and trim the edges of excess adhesive. Place transfer foil onto the surface of the tag and rub the foil against the adhesive stripes, burnishing the foil with your thumb. Peel off the foil sheet.

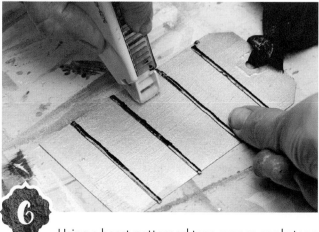

6 Using a heart-patterned tape runner, apply tape to the surface of the tag next to the adhesive lines.

7 Apply transfer foil to the taped areas of the tag, then burnish with a burnishing tool before removing the foil.

Encaustic

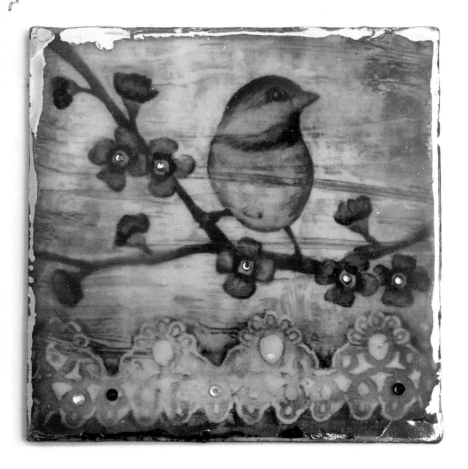

Applying an encaustic medium over a collage or a painting creates an ethereal, semitransparent and shiny coating over your artwork. The encaustic medium is a combination of filtered beeswax and damar resin. Not only does it provide a beautiful surface, but it is easy to adhere foil to.

WHAT YOU NEED

- color copy of artwork
- craft glue
- craft iron
- crystals
- encaustic medium
- encaustic paintbrush (inexpensive bristle brush)
- gold spray paint
- heat gun
- HotFix crystal tool
- mini slow cooker
- soft cloth
- transfer foil
- wood panel

Tips & Tricks

- This is a great way to reproduce original artwork to sell or give away as gifts. The encaustic medium makes it look special.

1. Heat up encaustic wax in a mini slow cooker. While it's warming, paint the entire wood panel with gold spray paint. Trim your color copy to fit the panel and glue it to the painted front. Allow the glue to dry.

2. Brush melted encaustic medium over the color copy.

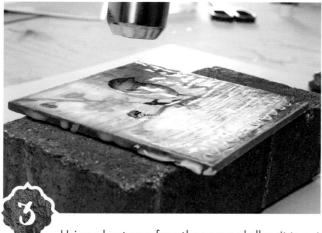

3. Using a heat gun, fuse the wax and allow it to set for a few hours.

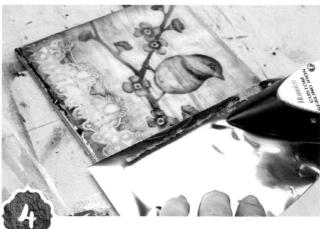

4. Polish the piece with a soft cloth. Set gold transfer foil (color-side up) along the edges of the panel and heat lightly with a craft iron to transfer the foil.

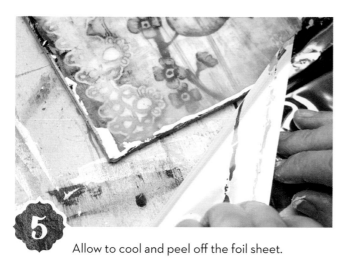

5. Allow to cool and peel off the foil sheet.

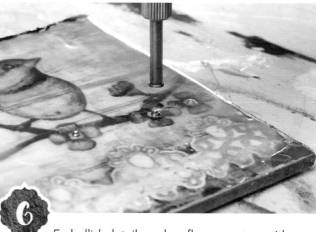

6. Embellish details such as flower centers with crystals using a HotFix crystal tool.

Glossy Photos

Transfer foil sticks to glossy photos with no adhesive, only the touch of a small quilting iron. This is another use for all those leftover foil negatives you've saved. Adhesive rub-ons also work beautifully on photos and don't require heat.

WHAT YOU NEED

- bleach pen
- craft iron
- gel pens (optional)
- glossy photos
- negative foil sheet
- paper towel
- transfer foil

1 Using a bleach pen, spread bleach in areas of your photo(s) where you want to take the color out.

2 Blot up the excess color with a paper towel. (You can stop when you hit the yellow layer or keep going until you reach the white, and final, layer.)

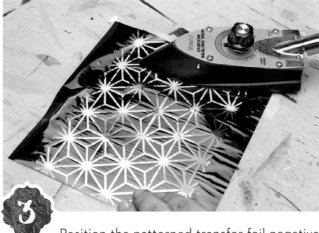

3 Position the patterned transfer foil negative onto the photo and iron over the surface with a craft iron on medium heat. (Iron only where you want the foil to adhere to the image.)

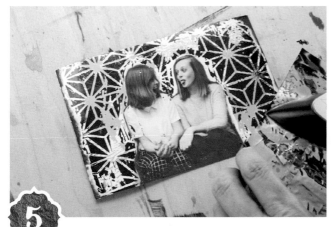

4 Allow to cool and peel off the foil sheet.

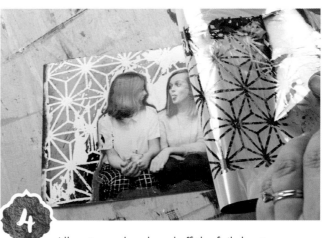

5 Using the craft iron, add more foil colors to fill in the negative spaces. Write personal messages with gel pens, if desired.

Tips & Tricks

- If you are sensitive to the smell of bleach, you can omit this step. I like to highlight the imagery by bleaching it, but you don't need to add bleach to make the foil stick.

Foil on Glass

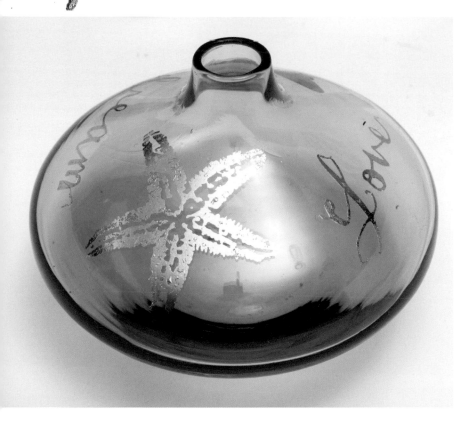

If you are looking for a nice handmade gift or a way to personalize some of your decorative glass jars and vases for your home décor, adhesive foil rub-ons provide a simple way to do this.

WHAT YOU NEED

- craft stick
- glass vase or other vessel
- adhesive rub-ons (Christine Adolph, Prima Marketing)
- scissors
- transfer foil

Tips & Tricks

- Do not wash or scrub glass or ceramics you've applied foil to without first applying an acrylic sealant or the foil will scratch.
- Try applying the foil rub-on to a cell phone case, spraying afterward with sealant for durability.

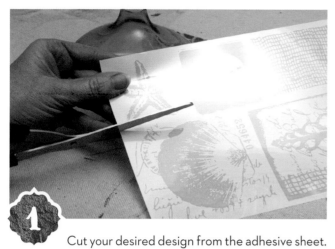

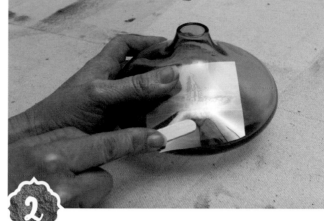

1 Cut your desired design from the adhesive sheet.

2 Peel away the protective backing sheet. Place the rub-on in the desired location on the glass vase. Burnish with a craft stick. Carefully peel away the top plastic layer.

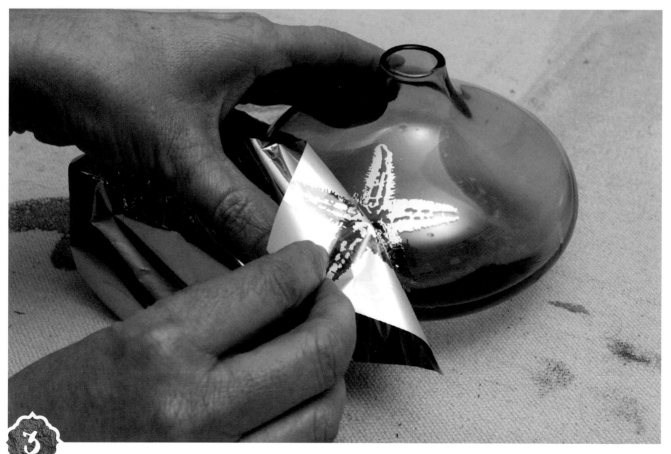

3 Place gold foil shiny-side up onto the adhesive rub-on and burnish with your finger. Carefully pull the foil off to reveal the foiled image.

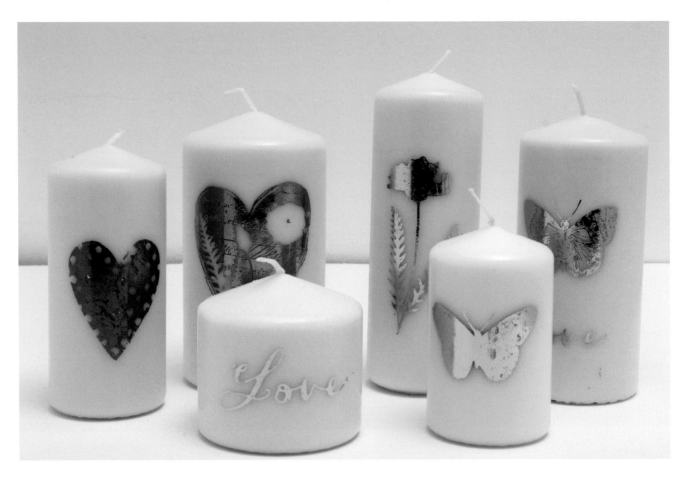

Foil rub-ons release easily onto wax candles and make nice party favors or table settings for a wedding.

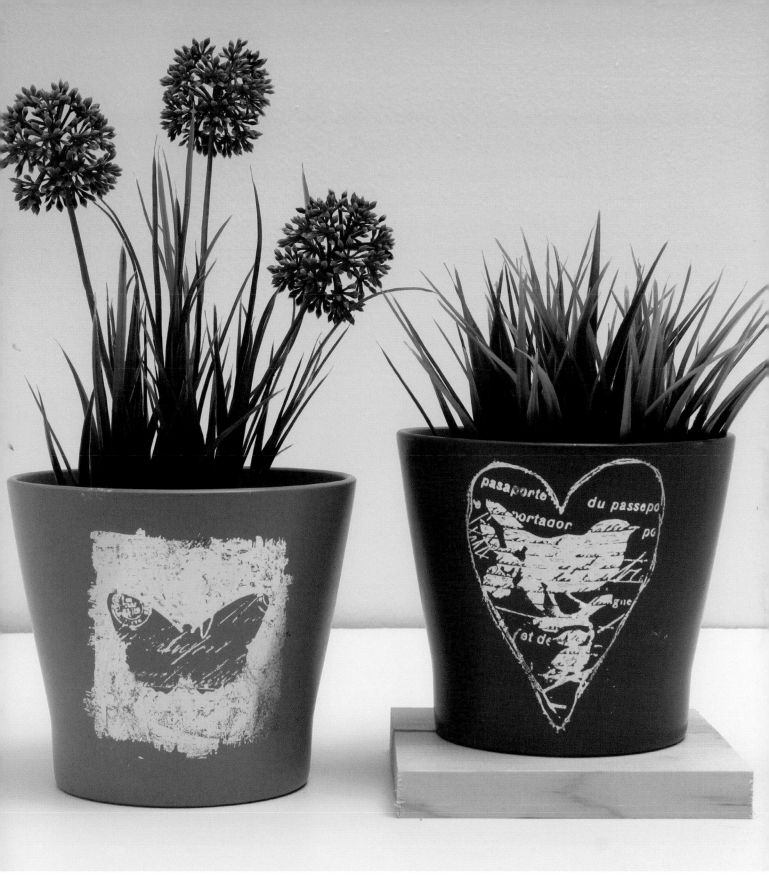

Think about other surfaces rub-ons can be applied to. Here I put them on simple planters. This would be a fun Mother's Day gift or gift for a teacher.

Watercolor Resist Pen

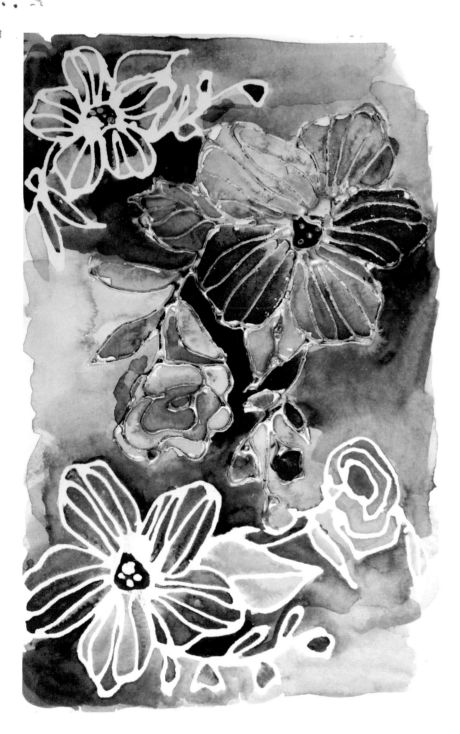

The watercolor resist pen lets you apply masking fluid in a controlled manner, and gives you the ability to make thin or thick lines and dots. After you paint your design, you simply peel the resist off to reveal the white of the paper. It emulates a batik look. While I was using this product I discovered that it is also a great foil glue. While this is not what the product was created for, it was a fun discovery. In this demo I will show you how to use it as a resist and a foil glue.

WHAT YOU NEED

- pencil

- transfer foil

- water brushes
 (Prima Marketing)

- watercolor paper

- watercolor resist pen (Christine Adolph, Prima Marketing)

- watercolors
 (Color Confections Tropical Palette, Prima Marketing)

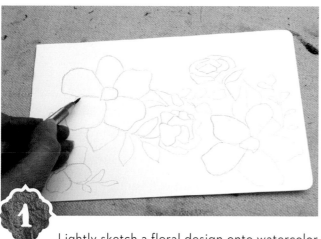

1 Lightly sketch a floral design onto watercolor paper. You want to keep it very light because watercolors are transparent and you can see the pencil lines if they are too dark.

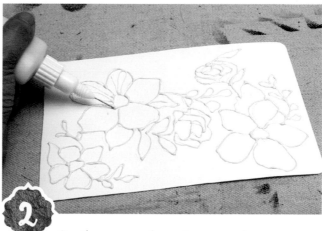

2 Gently squeeze the resist pen to draw over your sketch and create lines and doodles in the leaves and flowers. Allow the resist to dry.

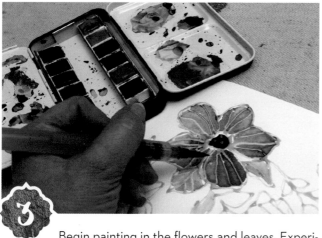

3 Begin painting in the flowers and leaves. Experiment with blending the analogous colors within the petals such as purple to pink.

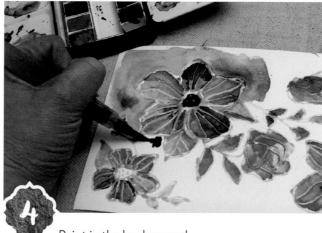

4 Paint in the background.

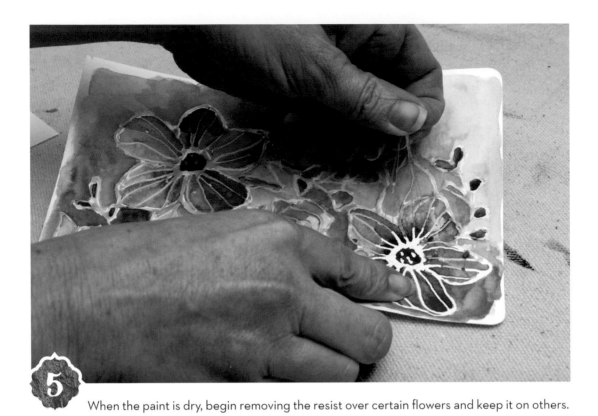

5 When the paint is dry, begin removing the resist over certain flowers and keep it on others.

6 Place transfer foil color-side up on top of the resist glue and lightly burnish. Pull up the foil to see the foiled outline.

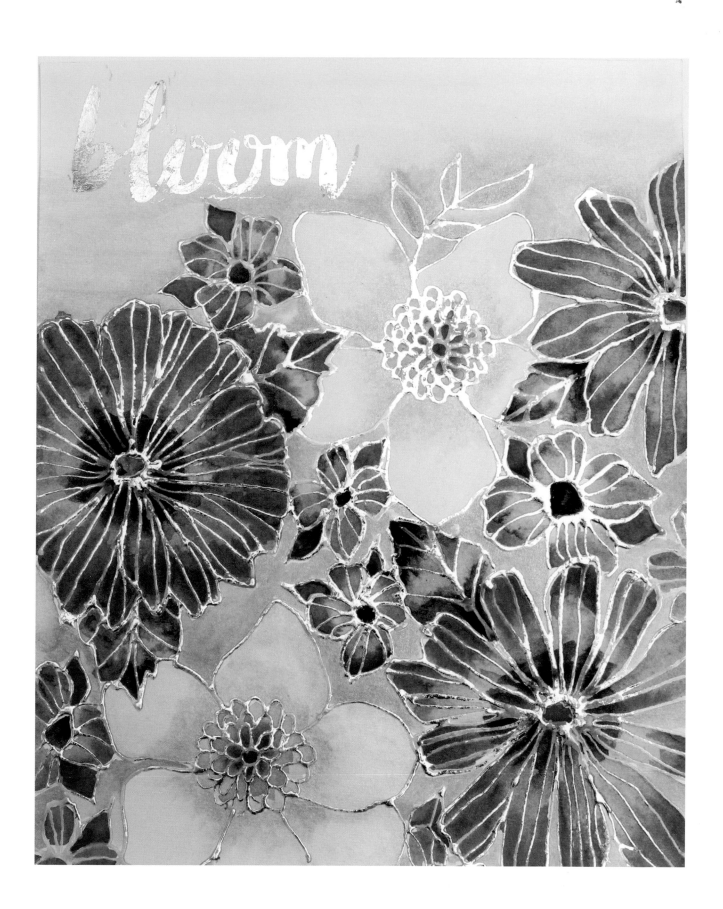

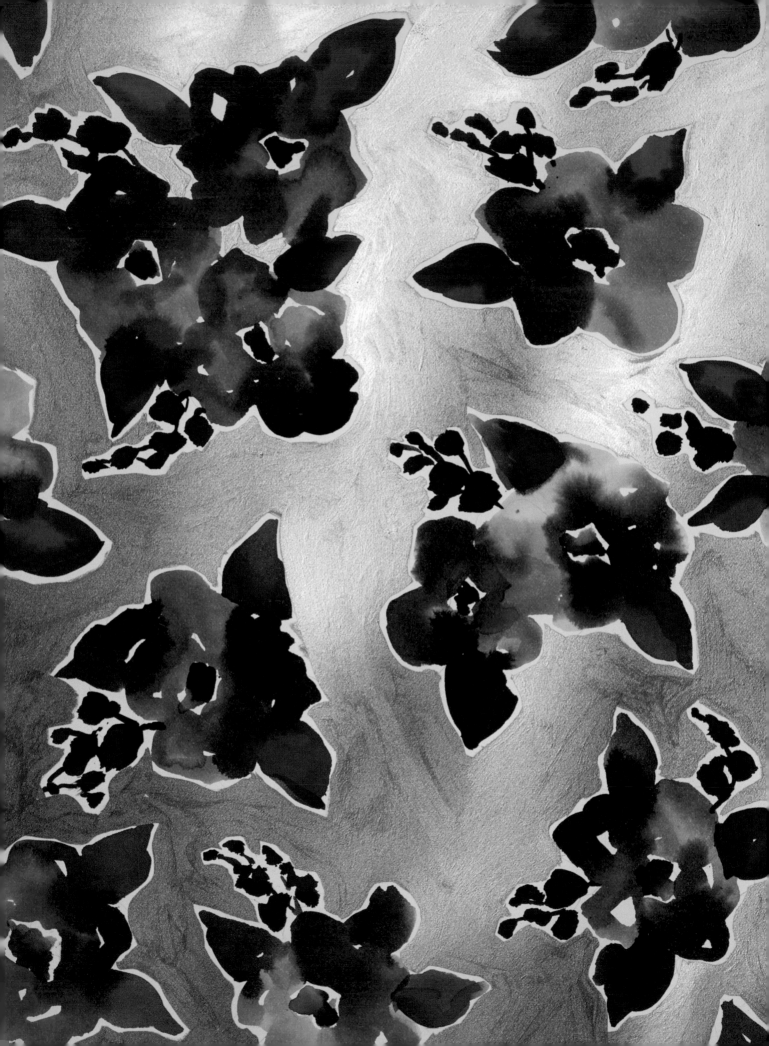

More Ways to Sparkle

{ ADDITIONAL MEDIUMS TO MAKE YOUR ART SHINE }

Transfer foils offer so much possibility and now that we have learned the many ways of using them, it is time to move on and learn more ways to create art that sparkles. In this section we will explore mica-based watercolor spray, metallic beeswax, shimmery acrylics, interference and iridescent mediums, glitter and liquid gold leaf. Not only will we be exploring all things sparkly, but we will also be using a wide range of tools and techniques such as hand-cutting stencils, making custom stamps, printmaking, drawing, cardmaking and creating custom home décor.

Color Bloom Sprays

I enjoy using a stencil burner tool to create floral silhouette stencils and masks from my drawings. I find it interesting to explore both positive and negative images with my hand-cut stencils. Although I like the look of spray paint, it isn't safe to use indoors. Color Bloom Sprays offer a nice alternative to spray paint. One day I decided that instead of wiping the sprays off my stencil, I would flip it over and brayer it on some newsprint to clean it off. It was a happy accident! Now I always flip the stencil over and brayer directly onto my artwork.

WHAT YOU NEED

- brayer
- Color Bloom Sprays (Prima Marketing)
- drawing or design for the stencil image
- Dura-Lar film (Grafix)
- glass sheet
- stencil cutter/burner tool
- tape
- vintage paper

Tips & Tricks

- Color Bloom Sprays have mica in them and need to be gently shaken before use. Otherwise, the gathered mica at the bottom can clog the sprayer.

- Try flipping the wet stencils over and brayering them on rice paper and again a second time on the same or different piece of paper to print a ghost print.

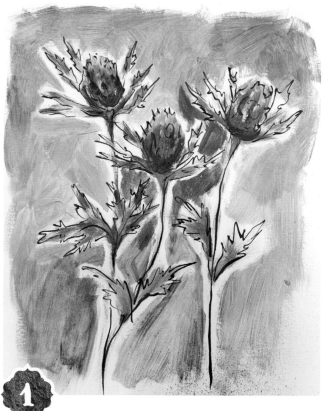

1 Find an image to use as your stencil design. I used one of my thistle paintings for this.

2 Place the design on your work surface, layer a piece of glass on top and tape a piece of Dura-Lar on top of the glass.

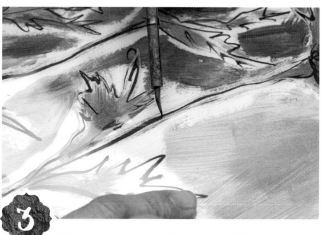

3 Warm up your stencil burning tool. Begin tracing your design with the hot stencil tool until you have completed tracing around the whole image.

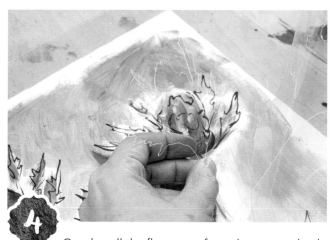

4 Gently pull the flower out from the acetate background. You will have a positive flower (or a mask) and a negative stencil. I use both designs to play with positive and negative contrast.

5 Place your stencil on your substrate.

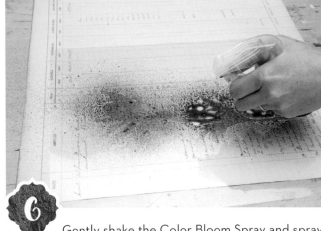

6 Gently shake the Color Bloom Spray and spray through the stencil, keeping it around 4"–6" (10cm–15cm) from the paper and moving it in a sweeping motion for even coverage of the spray.

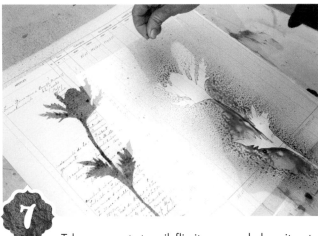

7 Take your wet stencil, flip it over and place it onto your paper.

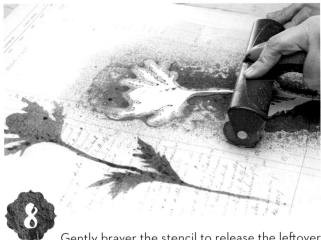

8 Gently brayer the stencil to release the leftover Color Bloom onto your paper.

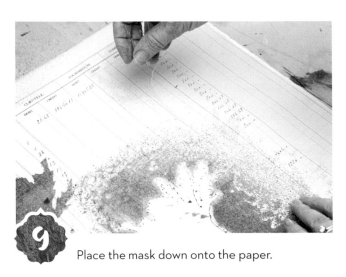

9 Place the mask down onto the paper.

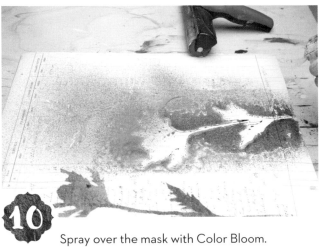

10 Spray over the mask with Color Bloom.

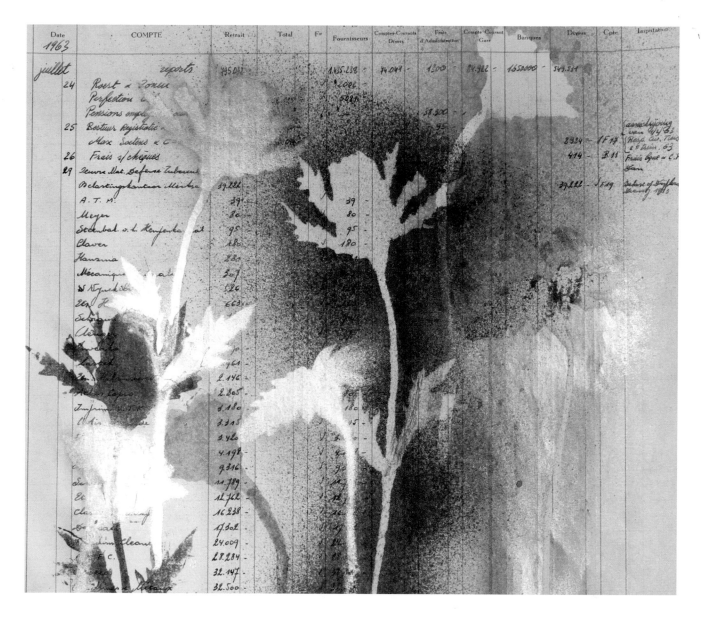

11 Lift off the stencil to reveal the silhouette.

12 Take the wet stencil, flip it over and brayer over it to monoprint the leftover paint to the surface. Continue this process until you have a successful composition.

Metallic Wax

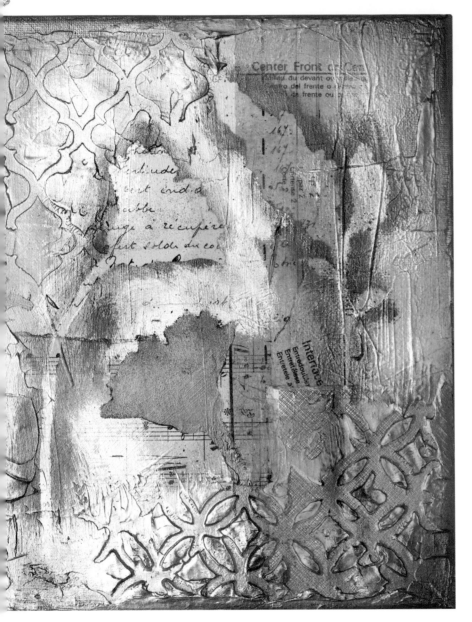

Metallic waxes for stencils provide a more controlled application of pigment through stencils than liquid paints, and the colors are brilliant. They have a beeswax base and are easy to clean up, too. The waxes are also fast drying, which is helpful.

WHAT YOU NEED

- canvas
- collage ephemera
- floral silhouette mask and stencil
- foam brush
- metallic wax
- Mod Podge
- molding paste (Prima Marketing)
- patterned stencil
- spackle knife
- stencil brush

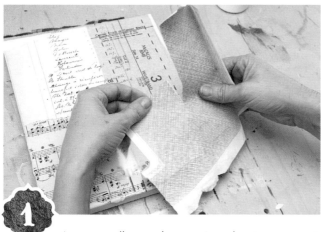

1 Arrange collage ephemera in a pleasing composition on the canvas.

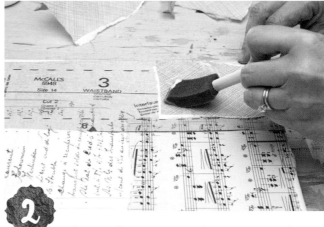

2 Adhere collage paper to the canvas panel using Mod Podge or other collage glue.

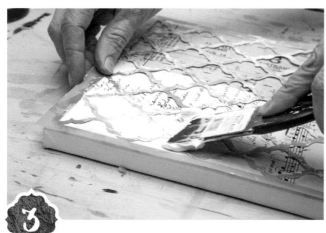

3 Using a spackle knife, apply molding paste through the patterned stencil in a few places on your canvas.

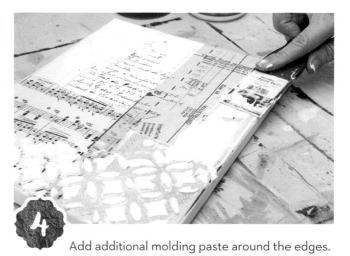

4 Add additional molding paste around the edges.

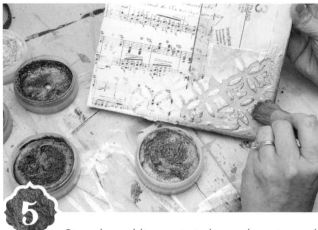

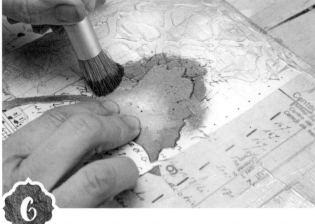

5 Once the molding paste is dry, apply various colors of metallic waxes over the textured patterns and also the sides and edges. Don't cover the whole canvas with metallic wax; just apply it here and there.

6 Place the floral silhouette mask down and brush metallic wax off the edges of it. You can blend colors together.

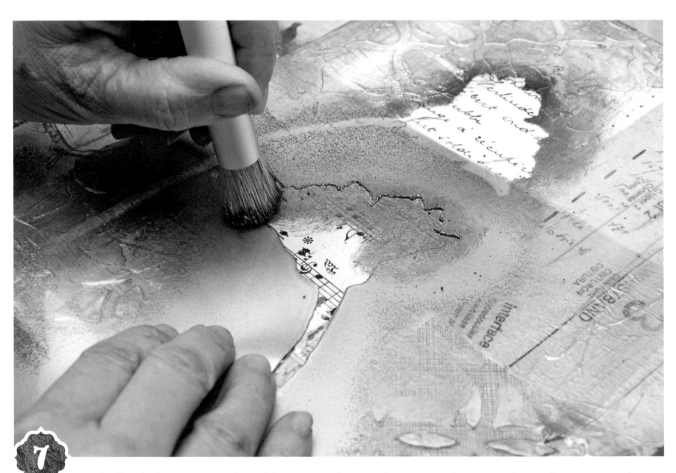

7 Use the floral silhouette stencil to add more metallic wax. Continue to alternate coloring the positive and negative stencils and vary the colors you use.

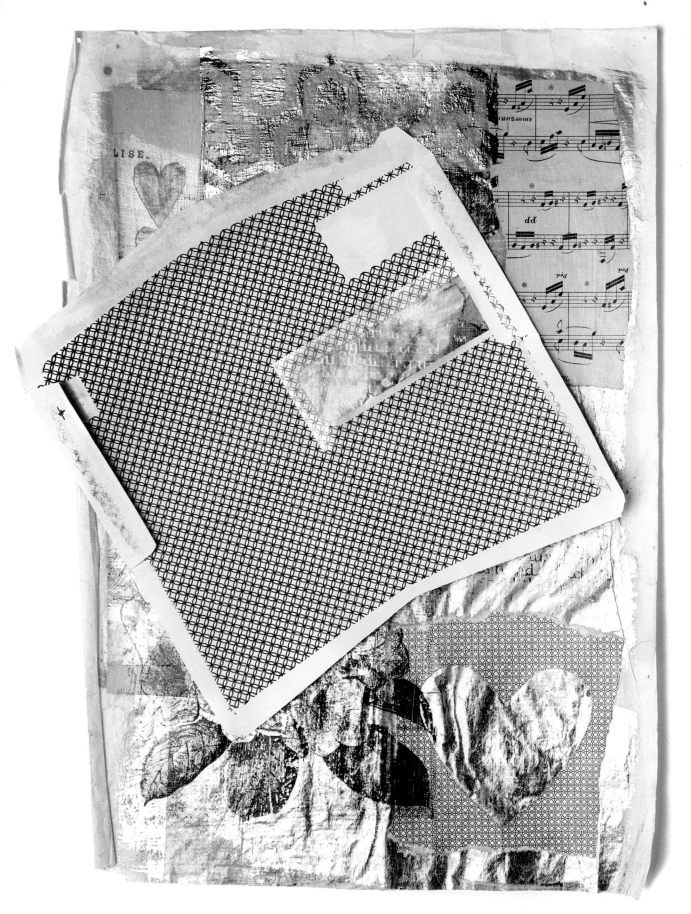

Rip open the envelopes your bills come in to reveal patterned paper you can use in your artwork!

Shimmering Matte Acrylics

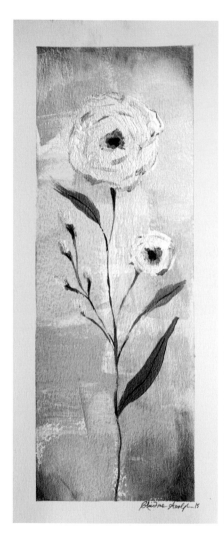

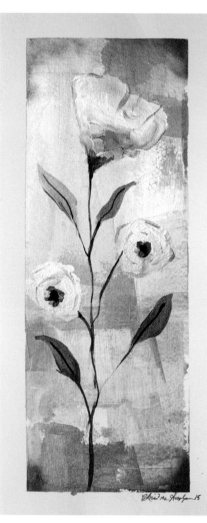

Perfect Paints are quality, artist-grade, shimmering matte acrylic paints made from fine pigments with no fillers or extenders. They are medium bodied, semi-opaque and can be used on multiple surfaces including fabric (without the need for fabric medium), metal and wood. I love the matte quality they provide while still being shimmery.

WHAT YOU NEED

- brushes
- paint scrapers (old gift cards/hotel keys)
- painter's tape
- Perfect Paints: Ballet Slipper, Bright Gold, Espresso, Halo, Shadow, Tarnished Silver and Vintage Mercury
- 140-lb. (300gsm) watercolor or bristol paper

Tips & Tricks

- Perfect Paints makes several mediums such as polishing plaster, weathered plaster, pearl plaster and textured gels that mix beautifully with their paints.

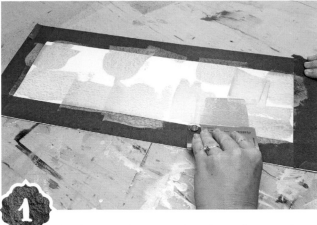

1 Apply painter's tape to the edges of watercolor or bristol paper. Use a paint scraper to apply Halo, Ballet Slipper, Tarnished Sliver, Vintage Mercury and Bright Gold in a patchwork pattern to your background. Repeat the colors in various places as this repetition gives balance and harmony to the background.

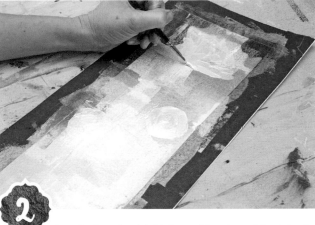

2 Load a brush with Halo and begin to block in the flower heads. Don't worry about details yet.

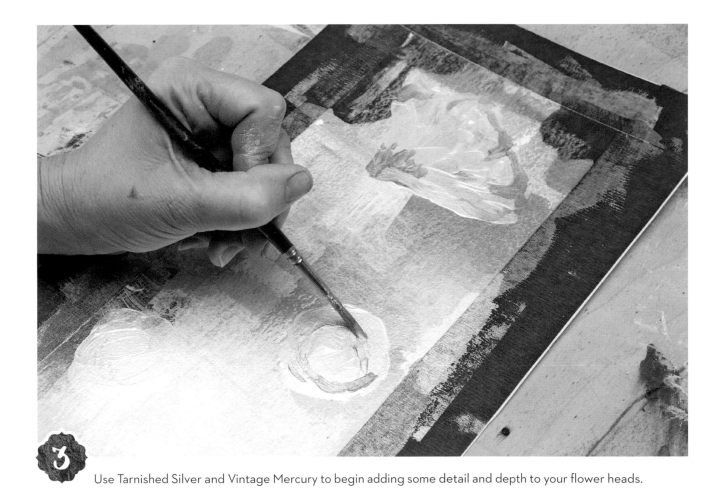

3 Use Tarnished Silver and Vintage Mercury to begin adding some detail and depth to your flower heads.

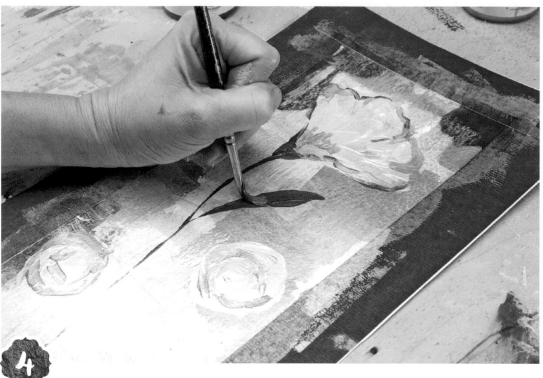

4 Using a small detail brush, paint the leaves with Espresso.

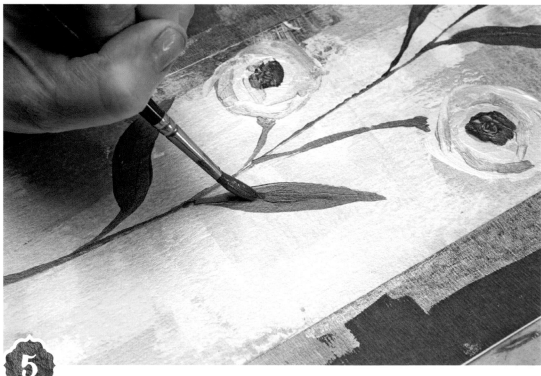

5 Also add Espresso to the center of the flower. Use Shadow to paint the veins of the leaves and the details of the flower centers. Allow the paint to dry and remove the tape.

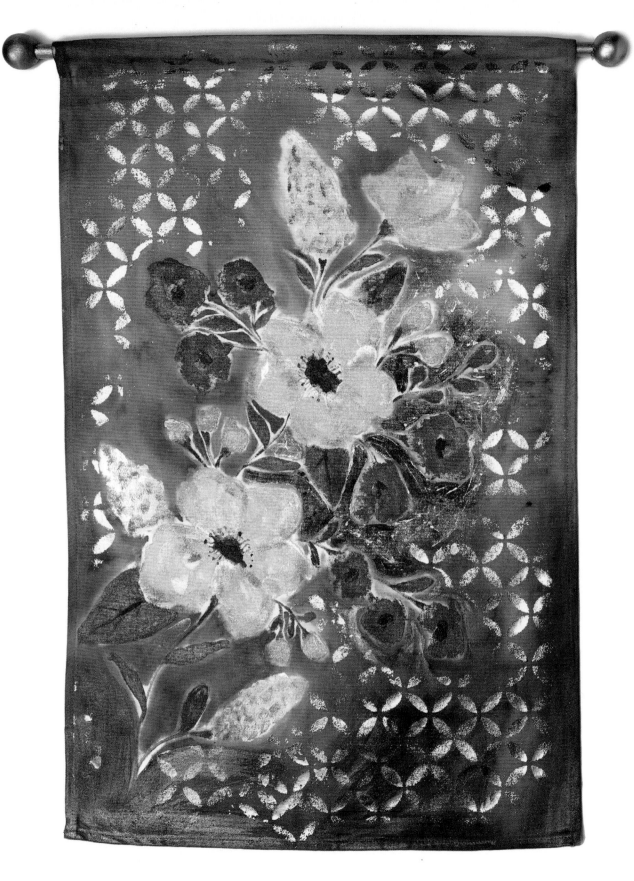

I used shimmering matte acrylic paints on this wall hanging. The paint can be used on fabric with no need for fabric medium. For the background, I added foil by spraying fusible spray adhesive through a stencil in various places in the background. I adhered the foil with an iron and I also masked out the flowers before spraying the background.

Iridescent and Interference Acrylics

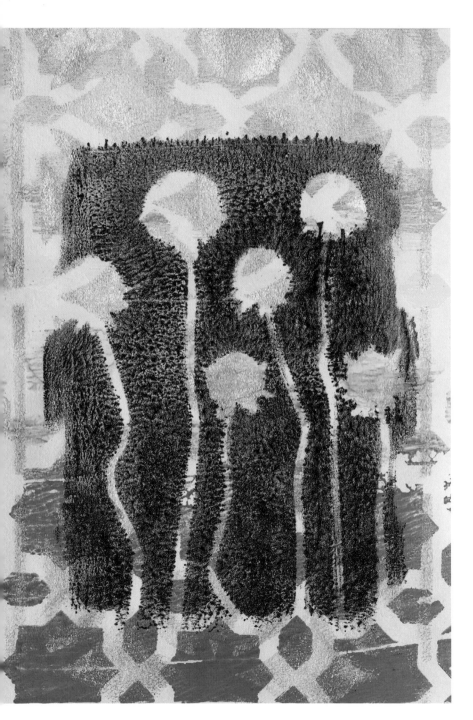

A Gelli Printing Plate looks and feels like gelatin but is durable, reusable and stores at room temperature. It's an easy-to-clean way to create monoprints with stencils and found objects. The iridescent paints I use are by Golden, and they can be used alone or with other colors, gels and mediums to create metallic finishes. The Micaceous Iron Oxide is made with highly reflective metallic pigments.

WHAT YOU NEED

- brayer
- Gelli Printing Plate
- Golden Artist Colors acrylic paints: Iridescent Gold, Micaceous Iron Oxide and three others of your choice
- paper palette
- pressed flowers
- rice paper
- stencils

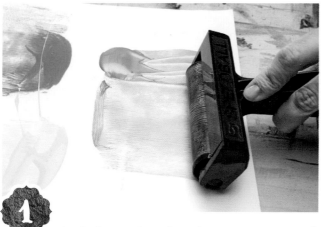

1. Apply three colors of acrylic paint to a paper palette. Begin with one color and roll it onto the brayer.

2. With the loaded brayer, roll the color onto the Gelli Printing Plate in a horizontal stripe. Repeat with the other two colors, rinsing off the brayer between colors.

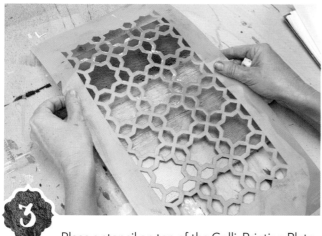

3. Place a stencil on top of the Gelli Printing Plate.

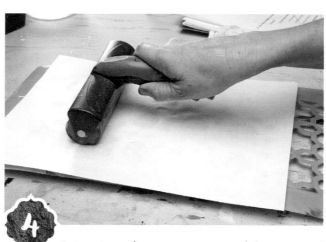

4. Put a piece of rice paper on top of the prepared plate. Brayer over the back of the rice paper.

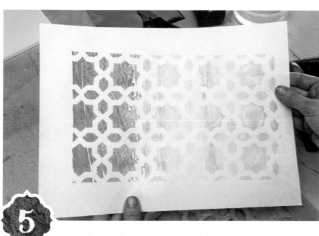

5. Gently peel the stencil off the plate to reveal the positive print.

Tips & Tricks

- Use baby wipes or wet paper towels to clean off the plate.

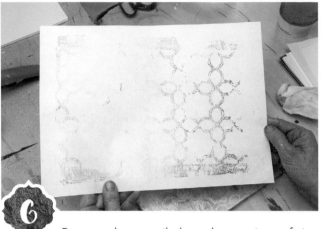

6 Remove the stencil, then place a piece of rice paper over the Gelli Printing Plate to adhere any leftover paint to the paper. Peel the rice paper back to reveal a negative ghost print.

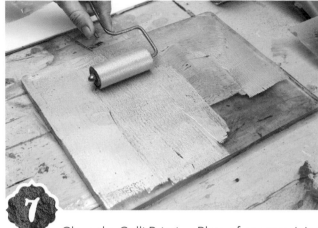

7 Clean the Gelli Printing Plate of any remaining paint. Then apply Iridescent Gold paint to the surface of the Gelli Printing Plate.

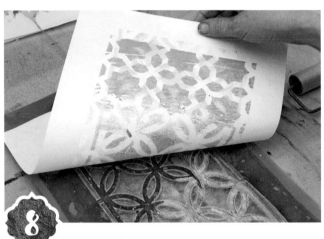

8 Place a different stencil over the gold paint and place the printed rice paper facedown on the plate. Brayer the rice paper to help adhere the underlying paint to the surface of the rice paper. Peel back the rice paper to reveal the print.

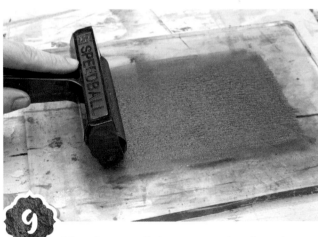

9 After cleaning off the printing plate from the previous print, apply Micaceous Iron Oxide paint to the center surface of the Gelli Printing Plate.

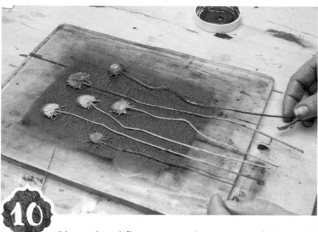

10 Place dried flowers on the center of the Gelli Printing Plate, over the painted area.

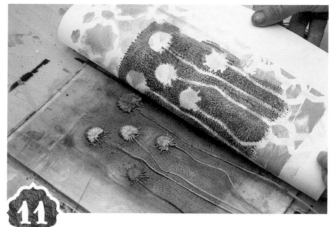

11 Place the print again facedown onto the Gelli Printing Plate, and brayer the back to adhere the paint. Pull back the paper to reveal the print.

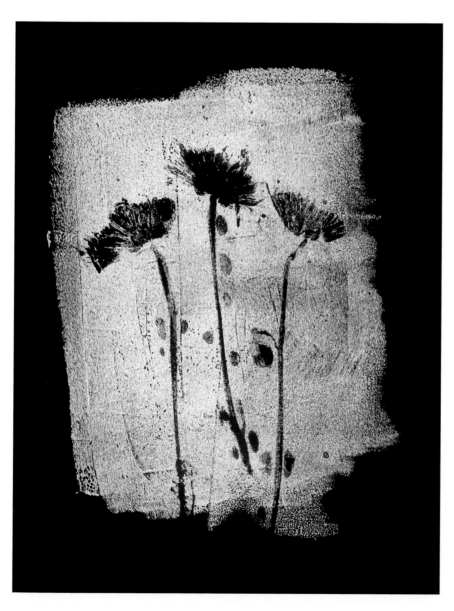

Simple one-color floral silhouette prints can be created using pressed flowers and Iridescent Gold on black paper.

Stabilo Pencil with Iridescent Acrylics

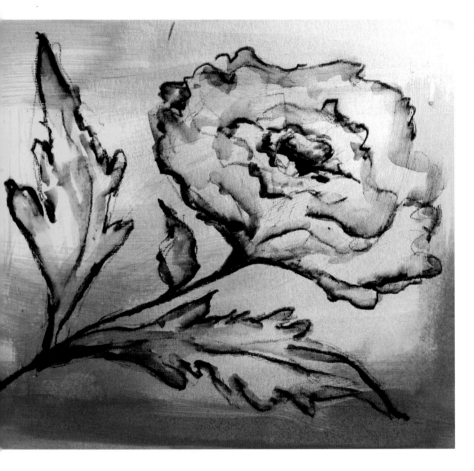

The Stabilo All pencil is a high-quality pencil that when activated with water is like paint. This pencil comes in a variety of colors and can be used on multiple surfaces, including glass, plastic, photographs, metal, leather, rubber and paper. Regular pencil is difficult to use on metallic surfaces, making the Stabilo ideal for sketching onto slick, shimmery, painted surfaces. I'm also using high flow acrylics; they have an ink-like consistency that works with a range of techniques like calligraphy, staining and mixed media.

WHAT YOU NEED

- 1" (25mm) flat brush
- high flow acrylics (Golden Artist Colors)
- iridescent acrylics (Golden Artist Colors)
- Stabilo All pencil (8008)
- water brush (Prima Marketing)
- watercolor or bristol paper

Tips & Tricks

- The graphite (8008) Stabilo is my favorite, but the Sepia (8045) and Blue (8041) follow as runners-up and are handy tools for my "art on the go" kit.

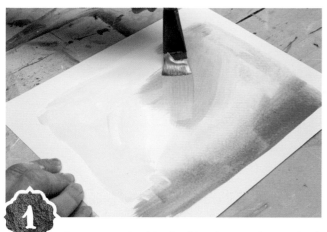

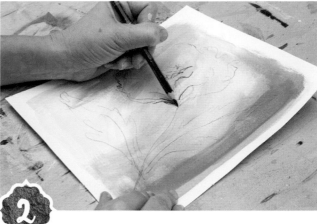

1 Create a color-blocked background using high flow acrylics. Add Iridescent Gold as one of the background colors.

2 Lightly sketch your floral composition. Add darker values to create a gradation between the darker and lighter areas. Do not fully outline your sketch in a dark heavy hand but vary the light-to-dark values by changing the line quality and pressure you use to draw with the pencil.

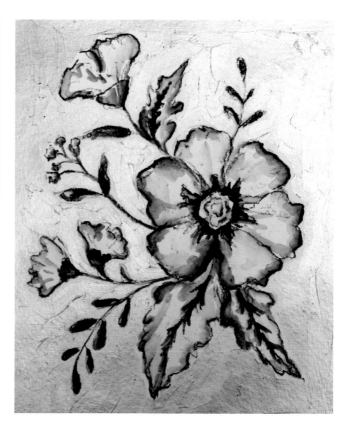

3 Take your water brush and wet certain areas of the pencil to create a wash effect. Use the water brush sparingly in areas where you would like to create a little bit of shading and value contrast.

For this piece, I sketched with the Stabilo first, then painted Iridescent Gold around the floral motif.

Rub-Ons with Glitter

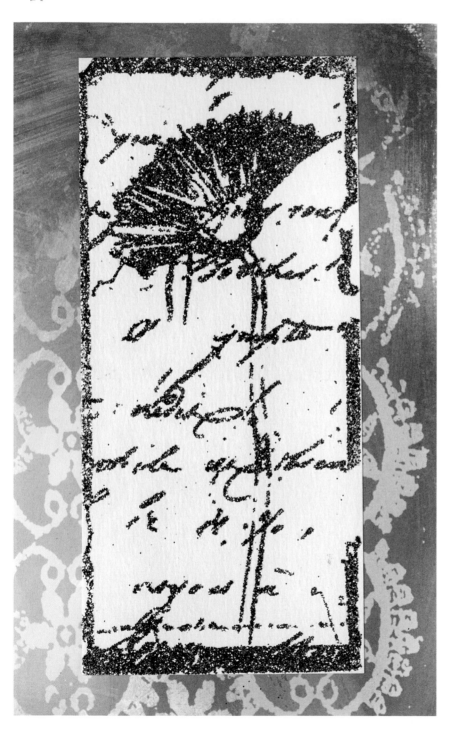

Adhesive rub-ons not only work with transfer foil, they work with fine glitter and mica powder, too! I have also seen adhesive rub-ons used with small microbeads. If you use the microbeads you might want to seal your finished work to keep the beads tightly glued onto the design.

WHAT YOU NEED

- adhesive rub-on (Christine Adolph, Prima Marketing)
- bone folder or craft stick
- cardstock or bristol
- glitter (Prima Marketing)
- scrapbook paper

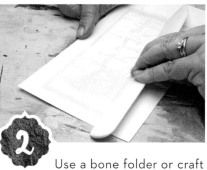

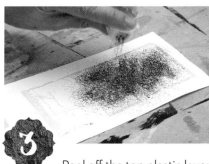

1 Peel off the back of the adhesive rub-on and apply it to the surface of your tag.

2 Use a bone folder or craft stick to burnish the rub-on to your tag.

3 Peel off the top plastic layer. Pour glitter on top of the paper, over the adhesive rub-on.

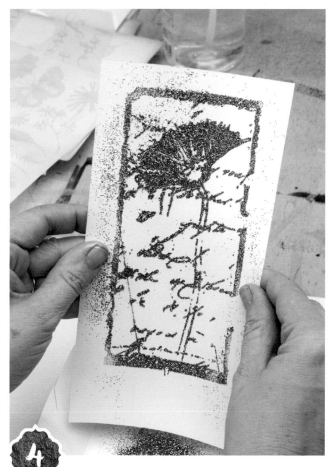

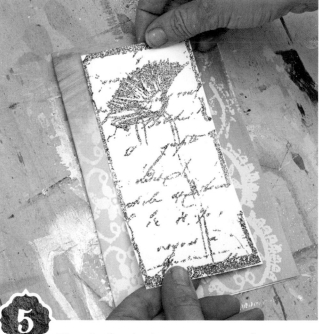

5 Glue the finished tag to a piece of patterned scrapbook paper and create a card.

4 Remove the excess glitter by pouring it off the paper. Repeat this step until the entire rub-on is covered to your liking.

Embossing Powder

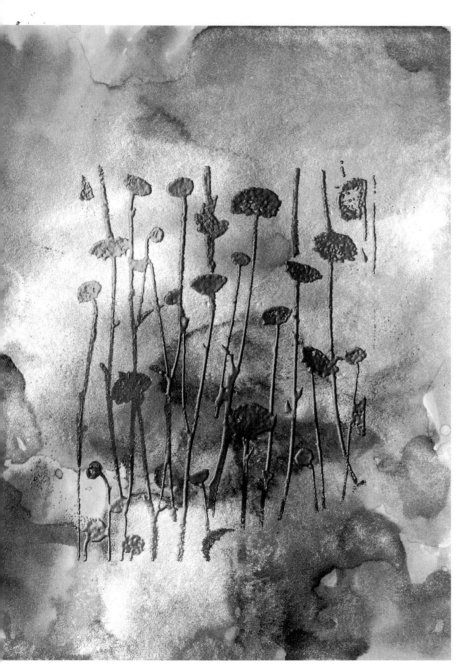

Metallic embossing powder is a fast-melting powder that can be applied to create a smooth raised image and dimensional quality to your work. Embossing powder can be used with clear embossing ink or a colored metallic pigment ink that is applied to paper by stamping, through a stencil or brushed on. It is a beautiful way to create different surface textures and sheens in your arts and crafts.

WHAT YOU NEED

- copper embossing powder (ColorBox)
- copper pigment ink pad (ColorBox)
- Button Mums rubber stamp (C8404 Stampington, Christine Adolph)
- heat gun
- paintbrush
- Twinkling H2O's Shimmering Watercolors
- watercolor paper

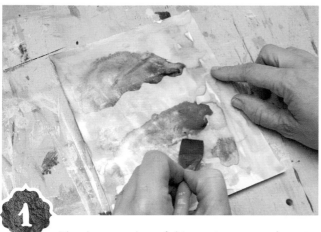

1 Blend warm colors of shimmering watercolor paint onto the watercolor paper background.

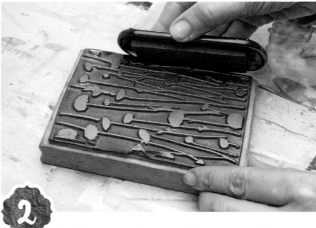

2 Apply copper pigment ink to your rubber stamp by leaving the stamp face up on your work surface and tapping the pad onto the stamp.

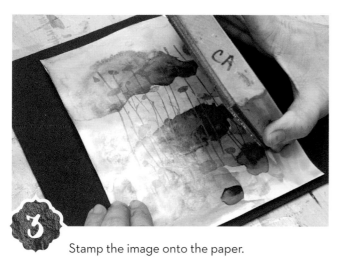

3 Stamp the image onto the paper.

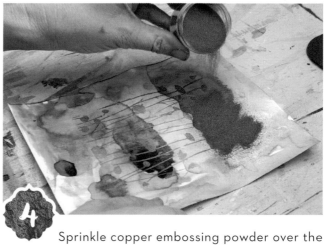

4 Sprinkle copper embossing powder over the freshly inked area.

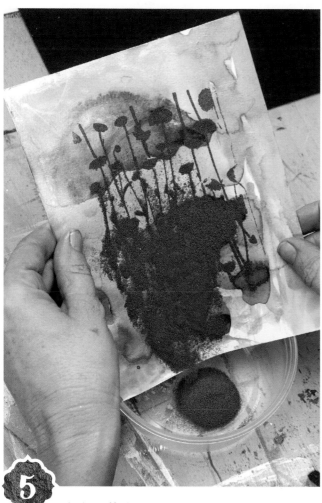

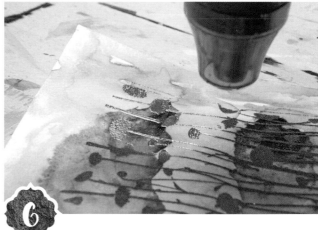

5 Shake off the excess embossing powder by tapping it onto a piece of scrap paper or over a bowl so you can later pour or funnel the excess powder back into the jar.

6 Heat the embossing powder with a heat gun until it melts and becomes shimmery. Keep the heat gun moving slightly to avoid scorching the powder and making it bubble.

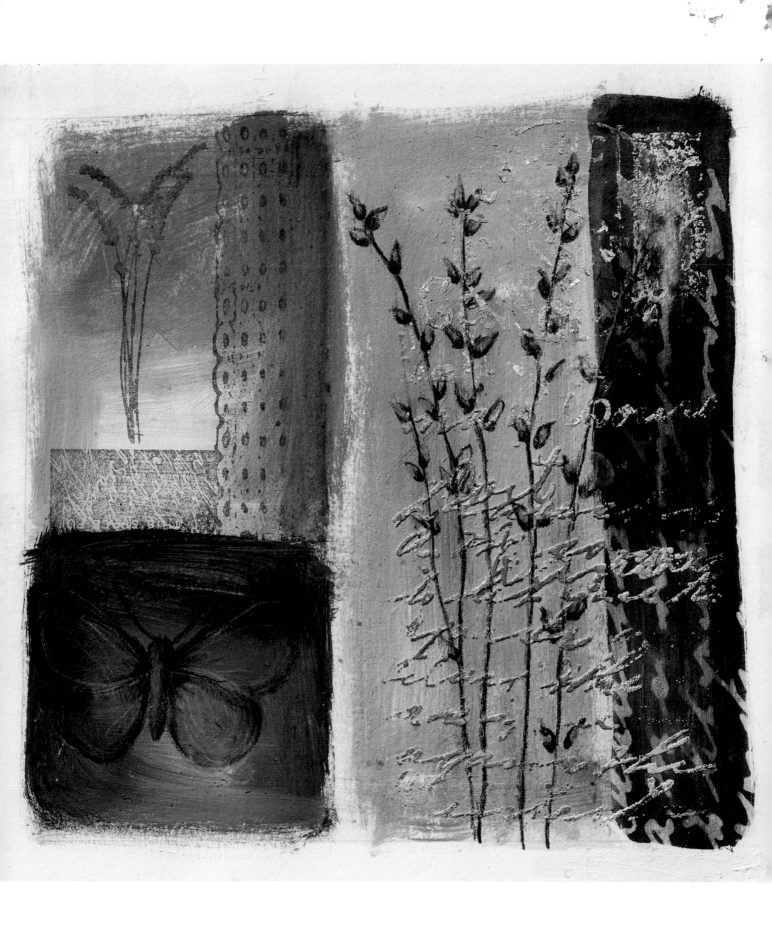

Stamped Metallic Paint

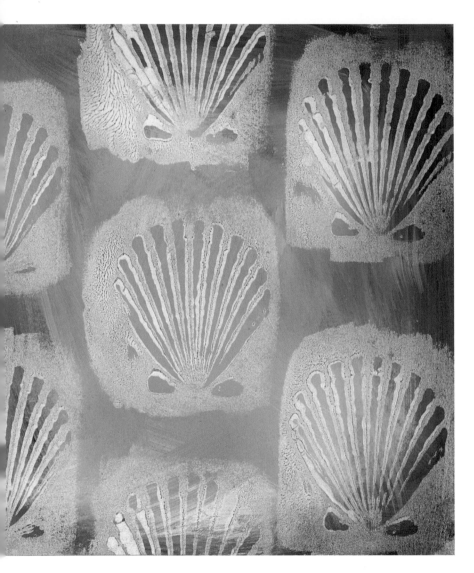

I discovered this fun product when I began teaching art many years ago. You can create your own stamps by heating the material and pressing it onto a textured surface to produce a reverse image. After you use it, you simply heat it again and the image disappears, and you are able to create another unique stamp over and over.

WHAT YOU NEED

- heat gun
- Iridescent Gold acrylic paint (Golden Artist Colors)
- moldable foam stamps (PenScore)
- paintbrush
- prepainted background
- seashell

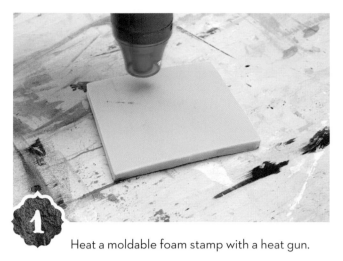

1 Heat a moldable foam stamp with a heat gun.

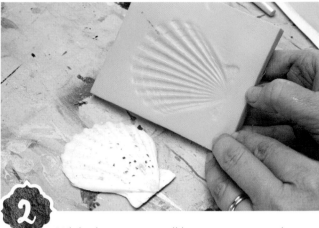

2 While the stamp is still hot, press it onto the seashell firmly and release.

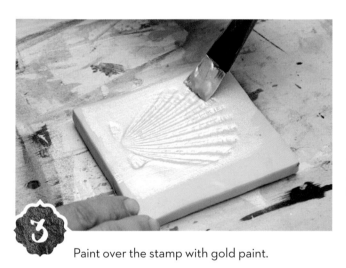

3 Paint over the stamp with gold paint.

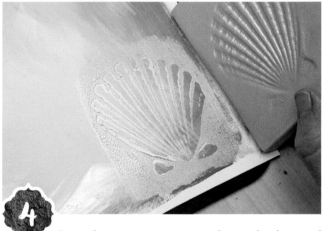

4 Press the stamp onto a painted paper background and continue stamping to create a pattern across the surface of the paper.

Tips & Tricks

- Consider pressing the foam stamps onto dried flowers, lace or even burlap to create interesting textured stamps.

- If the image doesn't turn out the way you like it, simply heat it again and you can start over.

- Stamp on brown kraft paper to create your own wrapping paper.

High Flow Acrylic Paints

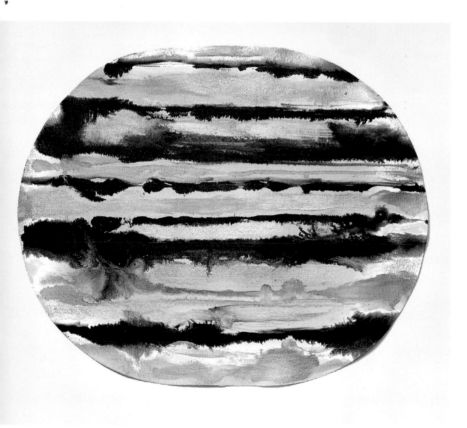

Watercolor effects can be difficult to achieve on primed canvas, but coating your canvas with absorbent ground will enable you to achieve a watercolor technique on primed canvas. Absorbent ground is a fluid acrylic medium that dries to a porous, paper-like surface. Applied over gessoed canvas, it facilitates raw canvas-like staining and watercolor effects that work perfectly with the high flow acrylic paints. Fredrix Artist Canvas placemats come in oval or rectangular shapes and they are double primed and ready for painting. This is a perfect way to bring art into your everyday life.

WHAT YOU NEED

- absorbent ground

- acrylic spray sealant

- bristle paintbrush (flat)

- Golden Artist Colors high flow acrylic paints: Indigo, Interference Blue, Iridescent Gold

- oval canvas placemats (Fredrix)

- spray bottle

1 Using a flat brush, coat the placemat with absorbent ground and allow to dry.

2 Once dry, mist the placemat with water so the high flow acrylics will blend and bleed (similar to a watercolor wet-on-wet technique).

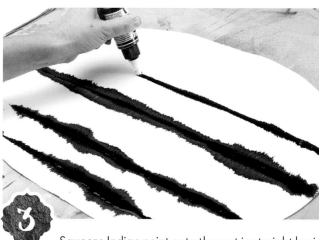

3 Squeeze Indigo paint onto the mat in straight horizontal lines.

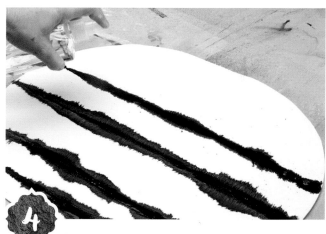

4 If it is not bleeding enough, you can mist it again so the color spreads.

Tips & Tricks

- You could make coasters or floor cloths with this technique.
- Don't be afraid to get your hands dirty. I didn't use any brushes for adding color here and used the handy paint squeeze bottle tip to draw with, the spray bottle to make the color bleed and my fingers to blend the paints.

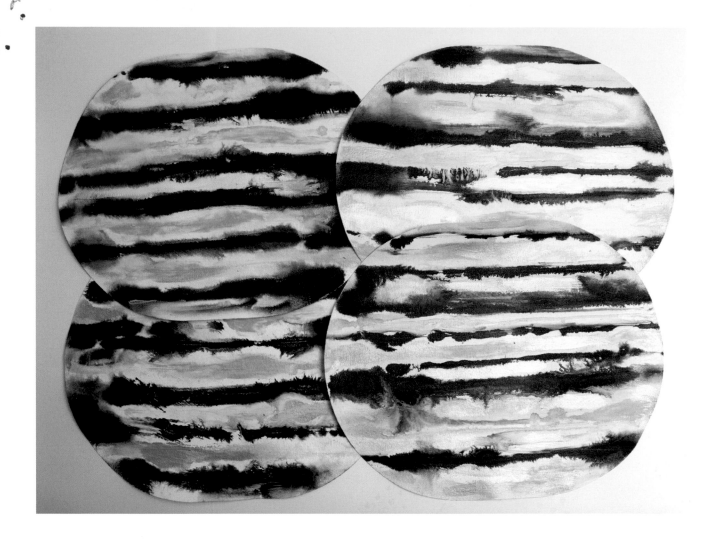

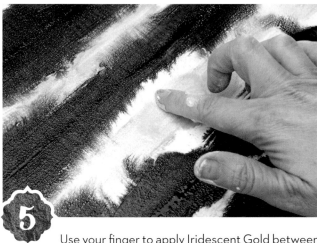

5 Use your finger to apply Iridescent Gold between the Indigo lines.

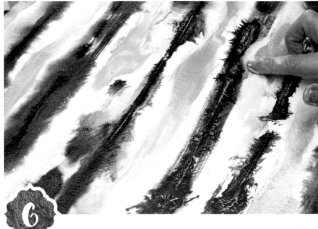

6 Add Interference Blue in random areas of the mat. Try adding a little onto the Indigo here and there to see how it changes. Once the paint is dry, seal it with an acrylic spray sealant.

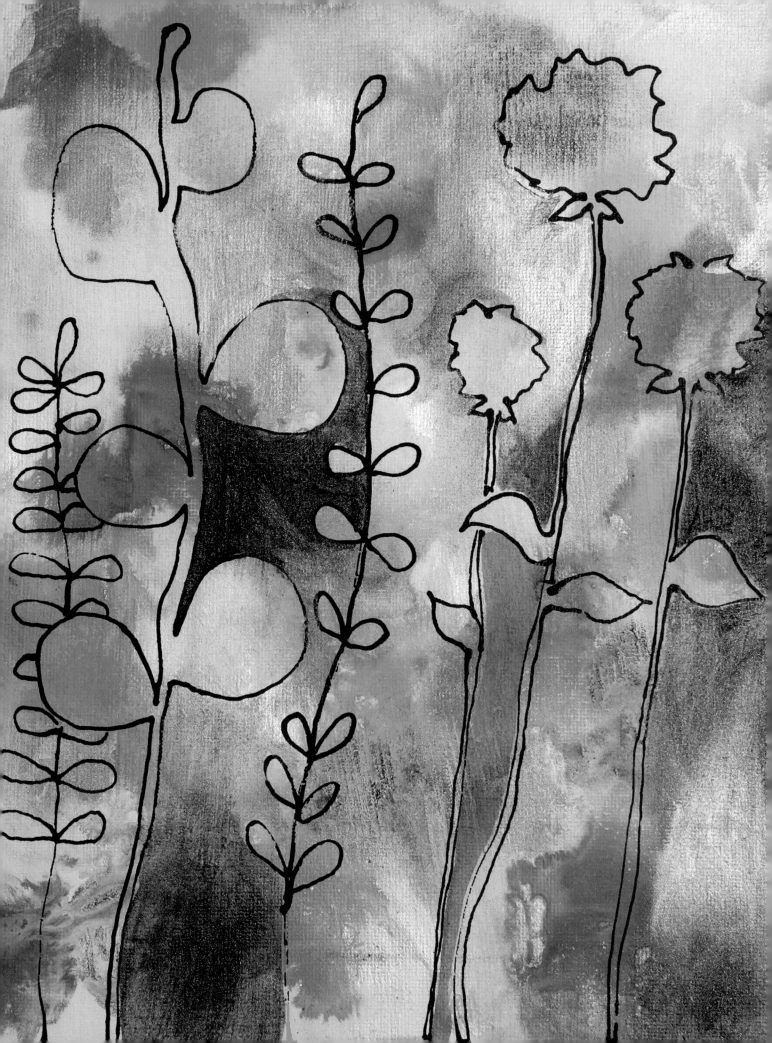

Liquid Gold Leaf

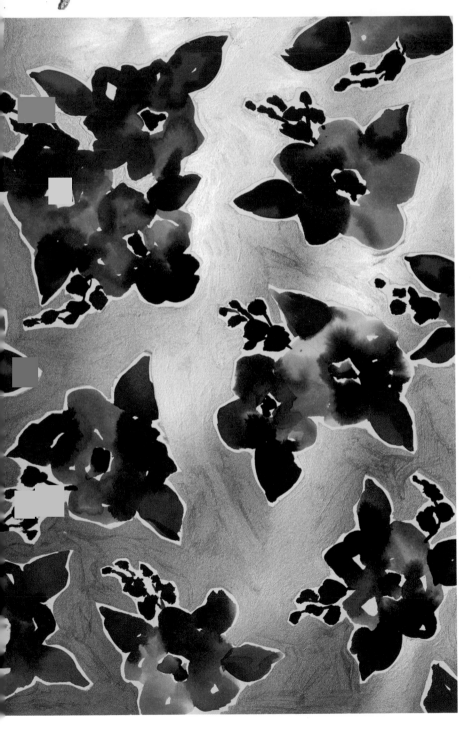

Liquid gold leaf is a simple one-step paint that gives the metallic luster of traditional gold leafing, but with more ease. It can be applied to a variety of surfaces such as wood furniture, stone, ceramic and paper. You can use it to highlight small details or, for full effect, it can be painted in large areas like I did here in my backgrounds.

WHAT YOU NEED

- liquid gold leaf
- paintbrush (inexpensive)
- watercolor paper
- watercolors (your choice of colors)

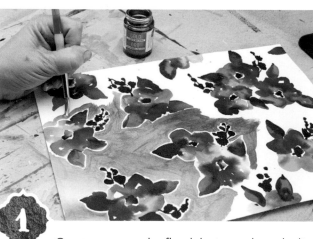

1 Create a watercolor floral design and use the liquid gold leaf to paint around your floral motifs to create a flat, metallic gold leaf background. Leave a white halo around the designs to make the flowers glow.

Tips & Tricks

- Use an old brush to apply liquid gold leaf as it can be difficult to remove from your brush.

- This medium has a strong odor. If you are sensitive to smells, consider using another medium.

- Consider working on multiple coordinating pieces with the same color palette at once. I created the smaller floral-tossed design and then made a coordinating dot pattern with the same paint I had mixed. Also (not pictured) I created a stripe and a large packed floral to go with this collection of art. Working on coordinating pieces allows you to explore one look or color palette in several ways.

Gallery

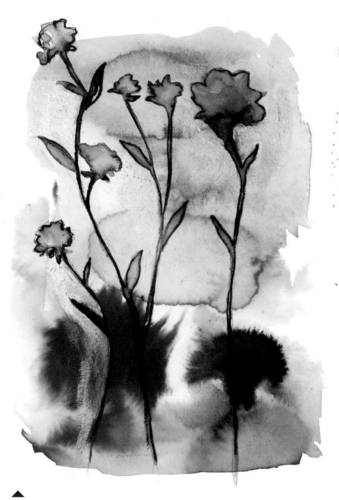

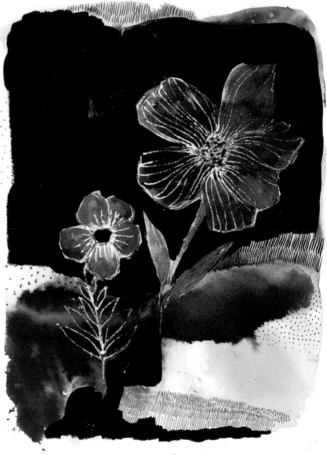

GARDEN SKETCH

Concentrated watercolor, Iridescent Gold acrylic and Stabilo All pencil on watercolor paper

RADIANT BLOSSOM

Concentrated watercolor, black gouache, foil glue pen and gold transfer foil on watercolor paper

SPRING DOODLE ▶

Prima Color Confections/Tropical palette, Christine Adolph adhesive rub-ons, transfer foil, foil glue pen and black permanent pen on watercolor paper

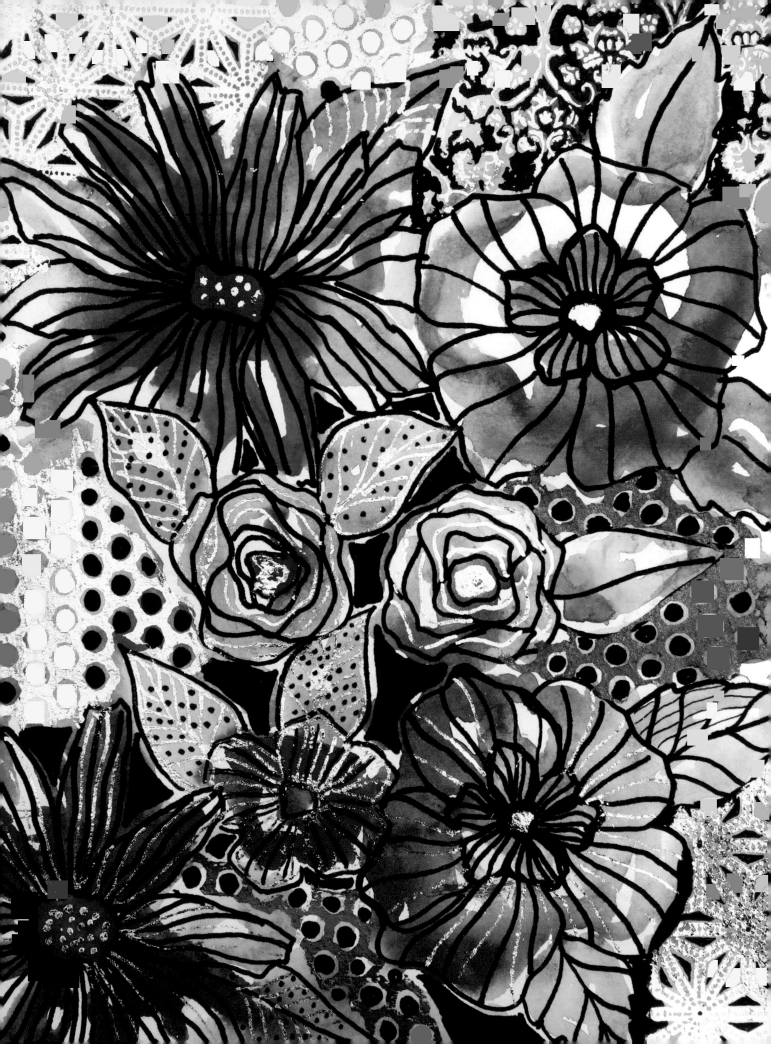

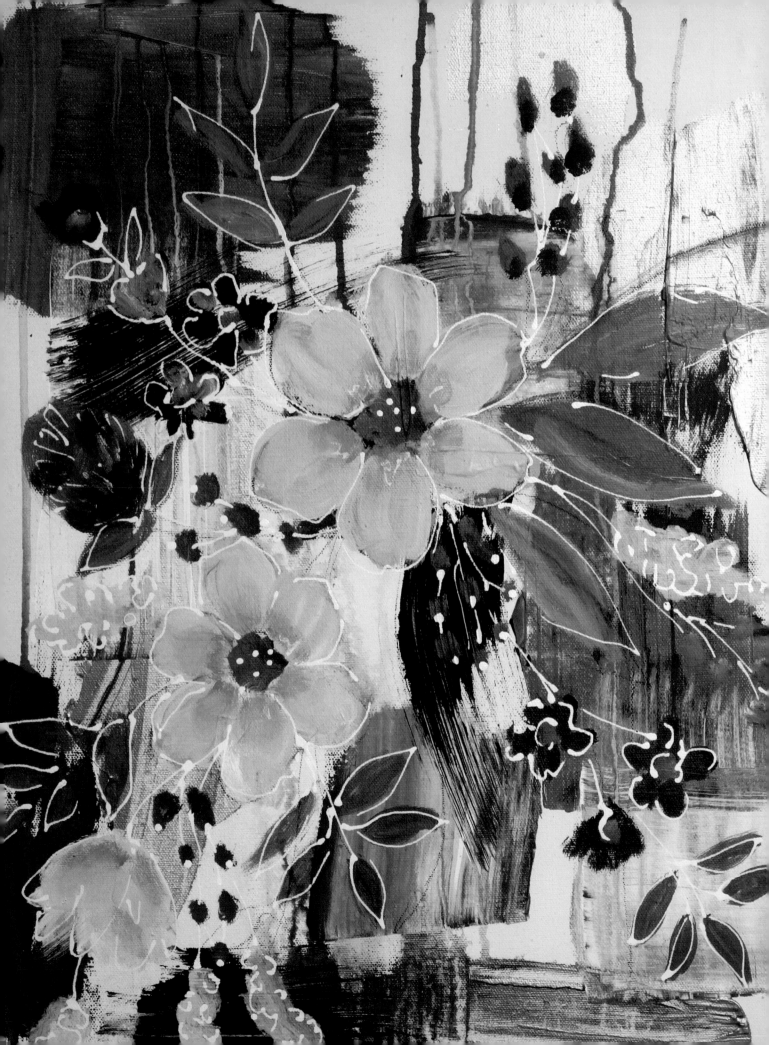

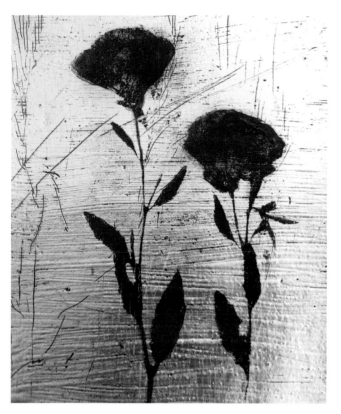

ILLUMINATED FLORAL

Transfer foil negative on fluid acrylic background

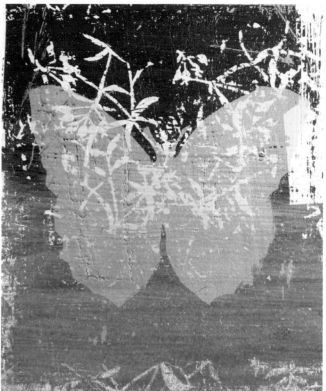

ILLUMINATED BUTTERFLY #1

Multiple transfer foil negatives applied over fluid acrylic background

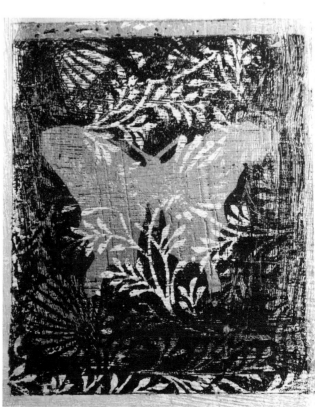

ILLUMINATED BUTTERFLY #2 ▶

Multiple transfer foil negatives applied over fluid acrylic background

◀ **CHEERFUL BLOOM**

Fluid acrylic and iridescent acrylic on canvas

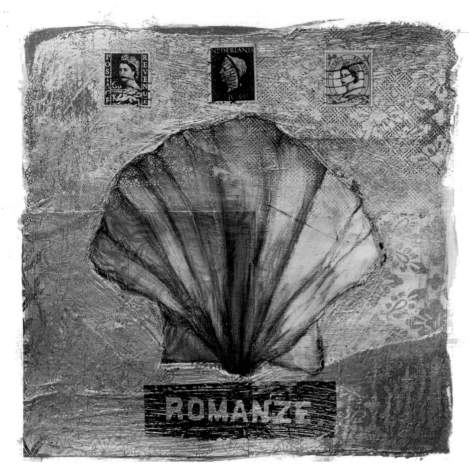

◀ **ROMANZE SHELL**

Fluid acrylic, postage stamps, patterned envelope insides, Stabilo All pencil and transfer foil negatives on Stonehenge paper

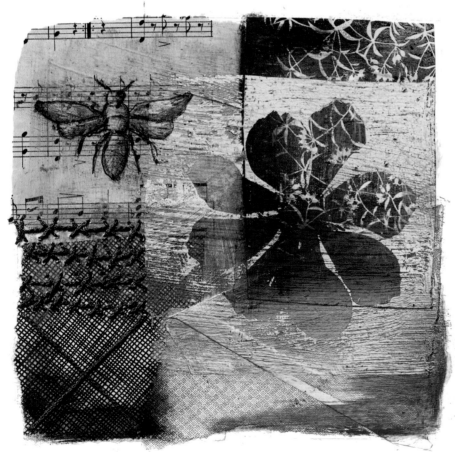

◀ **ROMANZE FLOWER**

Fluid acrylic, vintage music, pattern envelope insides, embroidery thread and transfer foil negatives on Stonehenge paper

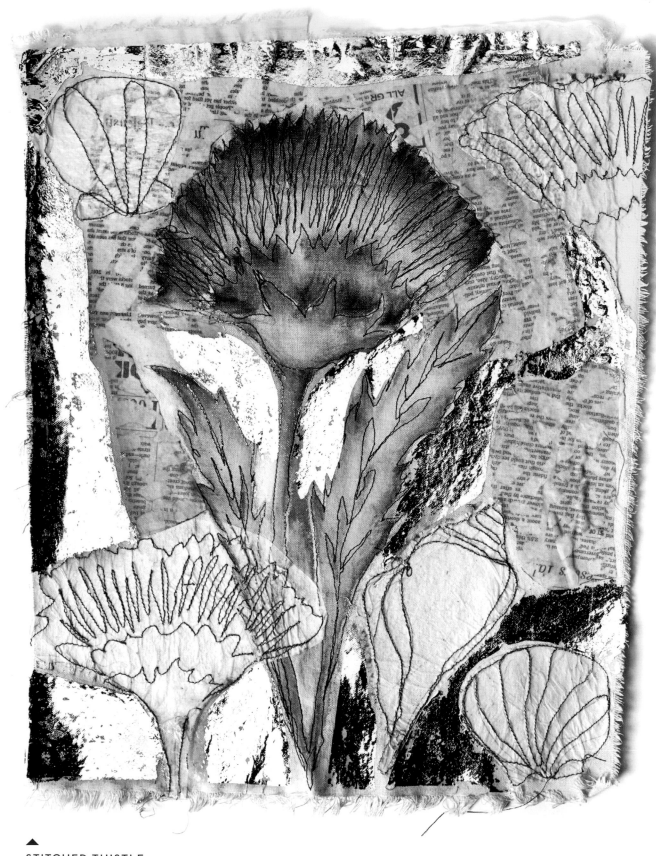

▲

STITCHED THISTLE

Water-soluble oil pastel, tissue paper, silk organza, Deco Foil Hot Melt adhesive sheets, silver transfer foil and stitching on unstretched canvas

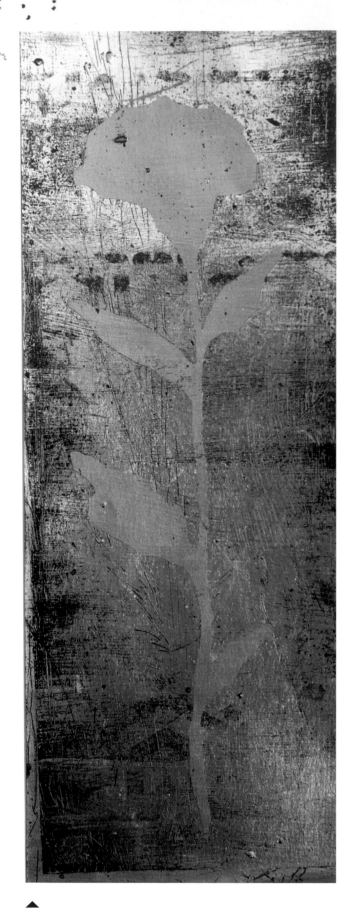

▲
GOLDEN VINE #1
Fluid acrylic and transfer foil negatives on bristol paper

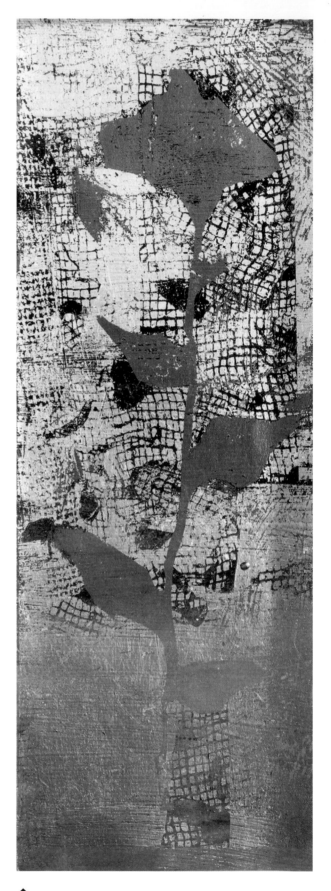

▲
GOLDEN VINE #2
Fluid acrylic and transfer foil negatives on bristol paper

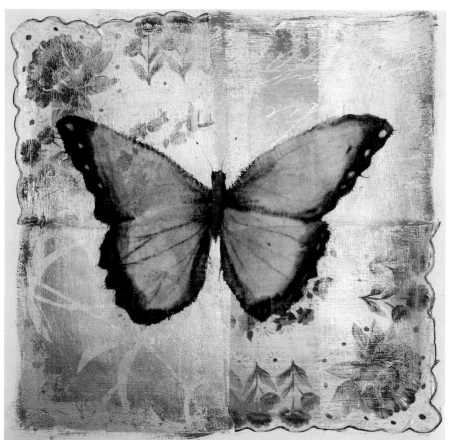

◀ **VINTAGE BUTTERFLY #1**
Acrylic, vintage handkerchief
and transfer foil negatives on
watercolor paper

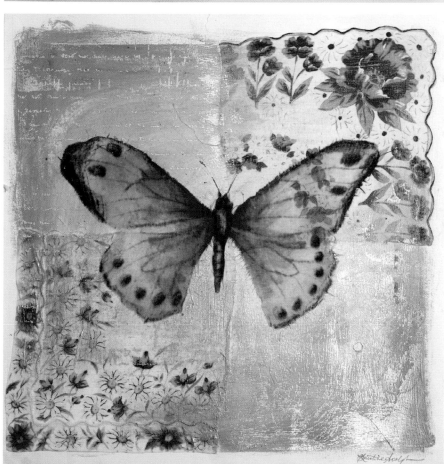

◀ **VINTAGE BUTTERFLY #2**
Acrylic, vintage handkerchief
and transfer foil negatives on
watercolor paper

Index

Dedication

To Erik, Alexandra and Lauren: You are my everything. To Cheryl Stone, for introducing me to the shimmer and shine of foil many years ago and for letting me bring my then-baby and toddler to your studio so I could have an artistic outlet. Your passion for printmaking with foil made an indelible impression on me.

a content + ecommerce company

DISTRIBUTED IN CANADA BY FRASER DIRECT
100 Armstrong Avenue
Georgetown, ON, Canada L7G 5S4
Tel: (905) 877-4411

DISTRIBUTED IN THE U.K. AND EUROPE
BY F&W MEDIA INTERNATIONAL LTD
Brunel House, Forde Close, Newton Abbot, TQ12 4PU, UK
Tel: (+44) 1626 323200, Fax: (+44) 1626 323319
Email: enquiries@fwmedia.com

ISBN 13: 978-1-4403-4476-3

Edited by Tonia Jenny
Designed by Breanna Loebach
Production coordinated by Jennifer Bass

Acknowledgments

A huge amount of gratitude goes out to the whole team at F+W Media, Inc. Special thanks to my editor Tonia Jenny; associate editor Brittany Van Snepson; photographer Christine Polomsky and designer Breanna Loebach. I appreciate all of your hard work and talent.

To Therm O Web, who went above and beyond in helping me get materials shipped to the photo shoot and for your willingness to promote the book. To my Prima Marketing family, thank you for valuing me as an artist and partnering on beautiful craft products together. To Stampington & Company and Creative Imaginations for giving me a launch into the craft and hobby industry many years ago, and to all the wonderful industry friends I've met through these companies.

Many thanks to Traci Bautista for encouraging me to submit a proposal and write a foil book; to Pam Garrison for all of your moral support and friendship; to Jessie Strike-McClelland, I hope I can be an artist as prolific, creative and hardworking as you when I'm in my 90s.

All of this would not have been possible without the efforts of my parents. As a child, they inspired my love of pattern and ephemera by giving me their old wallpaper books to play with, putting me in endless art classes, proudly displaying my flower drawings and eventually sending me off to art school. Thank you also to my wonderful extended family for being supporters of all I do—I love you.

Deep love and appreciation goes to my husband, Erik and my girls, Alexandra and Lauren. Thank you for understanding my need to create and for being my artistic counterparts in our family journey through life.

Most importantly, thank you to my Creator, for giving me hands and a heart to create.

Metric Conversion Chart

TO CONVERT	TO	MULTIPLY BY
Inches	Centimeters	2.54
Centimeters	Inches	0.4
Feet	Centimeters	30.5
Centimeters	Feet	0.03
Yards	Meters	0.9
Meters	Yards	1.1

About Christine Adolph

Christine Adolph has lived near the ocean her entire life in the California seaside village of San Clemente, where the coastal flora and fauna of her childhood playground gifted her with a lifetime love for drawing flowers and nature. Her time studying textile design at the Rhode Island School of Design broadened her experience to include vintage ephemera, historic patterns and unique surface design techniques. Using eclectic patterns, natural forms and embellished foil surfaces, Christine brings a fusion of design elements to her work. In 2004 she began licensing her art to the craft and hobby market for scrapbook paper, quilt fabric, rubber stamps and die-cut designs. She signed on with her agent MHS Licensing in 2011. Her art is now on a wide variety of gift, stationery and home décor products. She continues to make art in her studio daily and enjoys teaching art at Santa Margarita Catholic High School. She has recently launched a new craft product line with Prima Marketing. In art and in life, Christine strives to follow her heart and be herself. Inspired by faith and grateful for all of life's blessings, Christine hopes this shines through in all she creates.

christineadolph.com
Instagram: @christineadolphdesign
Facebook: Christine Adolph Design

Ideas. Instruction. Inspiration.

Receive FREE downloadable bonus materials when you sign up for our free newsletter at ClothPaperScissors.com.

Find the latest issues of *Cloth Paper Scissors* on newsstands, or visit shop.clothpaperscissors.com.

These and other fine North Light products are available at your favorite art & craft retailer, bookstore or online supplier. Visit our websites at artistsnetwork.com and artistsnetwork.tv.

Follow CreateMixedMedia.com for the latest news, free wallpapers, free demos and chances to win FREE BOOKS!

GET YOUR ART IN PRINT!
